2004

10·14·94

Gabriel Orozco **Photogravity**

QUE DESTRUYE UNAS IDEAS CON OTRAS

TOTALIDAD DE UNIDADES

THAT DESTROYS SOME IDEAS WITH OTHERS

TOTALITY OF UNITIES

Gabriel Orozco **Photogravity**

Afterword by ANN TEMKIN

PHILADELPHIA MUSEUM OF ART

ESPECTANT ESPECTATOR - ESPECTANT OBJECT.

ESPECTATOR WITH ESPECTATION.

WAITING SUBJECT + WAITING OBJECT = NOTHING HAPPENS. THE ESPECTATOR START T...

ESPECTATOR WITH ESPECTATION.

THE PIECE RESPOND WITH INDIFFERENCE. BUT SOMETHING IS HAPPENING: THE EVEN...

MOVEMENT. IN WICH NOTHING (APPARENTLY) IS HAPPENING.

EL ESPECTADOR ES EL PUNTO DE FUGA,

EN ESCULTURA EL PUNTO DE FUGA ESTÁ EN LA BASE, EN EL PUNTO DE CONTACTO GRAVITA...

Y SE SOSTIENE LA ESTRUCTURA DE LA PIEZA. CUANDO EL ESPECTADOR CAMINA ALRE...

TRIDIMENSIONAL LA VISIÓN DE ESTE VA CAMBIANDO, PERO EL PUNTO GRAVITACIA...

EL ESPECTADOR AL MOVERSE, HACE MOVERSE A LA ESCULTURA. LA BASE (...

QUEDA INMOVIL. ¿QUE PASA SI EXCLUIMOS LA BASE? ¿QUE PASA SI NO...

LA UBICAMOS A NUESTRO ALREDEDOR? QUE PASA SI NO MOVEMOS NUES...

SIN BASE? (EL CENTRO EN TODAS PARTES, LA CIRCUNFERENCIA EN NINGUNA.

ES EL DESIERTO). EL CENTRO GRAVITACIONAL DE UNA ESCULTURA...

COMPLETAMENTE ABIERTA Y SIN BASE SOMOS NOSOTROS. QUE LA RECO...

ESTAMOS EN EL INTERIOR Y EN EL EXTERIOR AL MISMO TIEMPO. Y US...

ESTAN SOSTENIDOS POR NUESTRA MIRADA A NUESTRA CONCIENCIA (SIENDO...

...PECTATOR — ESPECTANT OBJECT.

...ITH ESPECTATION.

...ECT + WAITING OBJECT = NOTHING HAPPENS. THE ESPECTATOR START TRYING TO ACTIVATE & PREO...
...ESPOND WITH INDIFFERENCE. BUT SOMETHING IS HAPPENING: THE EVENT IS MOVING. THERE IS
...IN WHICH NOTHING ('APPARENTLY) IS HAPPENING.

...OR B EL PUNTO DE FUGA.

...EL PUNTO DE FUGA ESTA EN LA BASE. EN EL PUNTO DE CONTACTO GRAVITACIONAL DONDE DESCANSA
...VE LA ESTRUCTURA DE LA PIEZA. CUANDO EL ESPECTADOR CAMINA ALREDEDOR DE UN OBJETO
...NAL, LA VISIÓN DE ESTE VA CAMBIANDO, PERO EL PUNTO GRAVITACIONAL SIGUE INMÓVIL.
...DOR AL MOVERSE, HACE MOVERSE A LA ESCULTURA. LA BASE (COMO EN EL PEÑÓN LO)
...ÓVIL. ¿QUE PASA SI EXCLUIMOS LA BASE? ¿QUE PASA SI NOS MOVEMOS LA ESCULTURA Y
...GS A NUESTRO ALREDEDOR? QUE PASA SI NO NOS MOVEMOS NOSOTROS DE UNA ESCULTURA,
...(EL CENTRO EN TODAS PARTES, LA CIRCUNFERENCIA EN NINGUNA. EL LABERINTO PERFECTO)
...GATO). EL CENTRO GRAVITACIONAL DE UNA ESCULTURA RECONSTRUYÉNDOLE Y SIN BASE
...MENTE ABIERTA Y SIN BASE SOMOS NOSOTROS. QUE LA RECORREMOS POR TODAS PARTES,
...EL INTERIOR Y EN EL EXTERIOR AL MISMO TIEMPO. Y LOS LÍMITES DEL ESPACIO
...ENIDOS POR NUESTRA MIRADA Y NUESTRA CONCIENCIA (SIEMPRE HABRÁ UNA ZONA DE
...QUE NO VEMOS) (COMO LA ESFERA DESPUÉS DE LA ACCIÓN).
...IÓN ENTRE EL

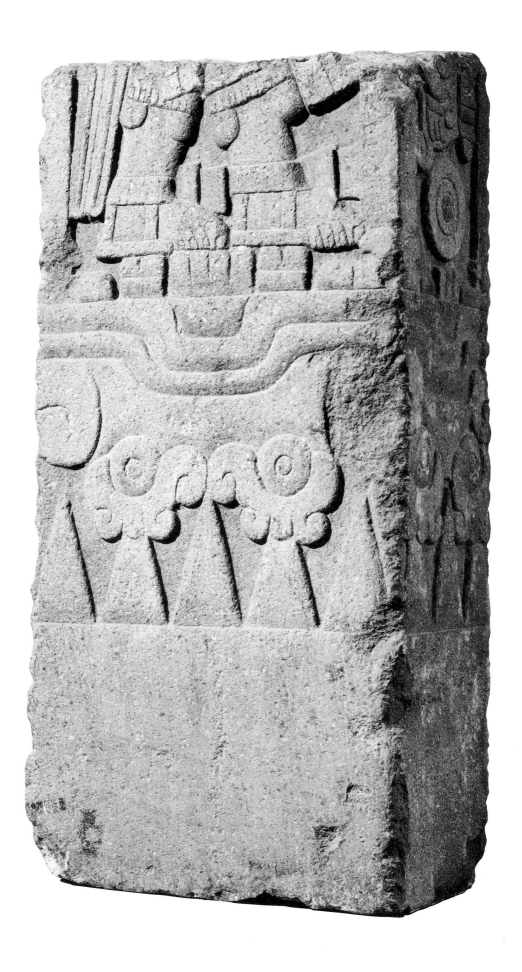

ESPECTADOR ESPECTANTE—OBJETO ESPECTANTE.
ESPECTADOR CON ESPECTATIVAS.
SUJETO QUE ESPERA + OBJETO QUE ESPERA = NO PASA NADA. EL ESPECTADOR EMPIEZA INTENTANDO
LA PIEZA RESPONDE CON INDIFERENCIA. PERO ALGO ESTA PASANDO: EL EVENTO
MOVIMIENTO, EN EL CUAL NADA ("APARENTEMENTE") ESTA SUCEDIENDO.

THE SPECTATOR IS THE VANISHING POINT.
IN SCULPTURE THE VANISHING POINT IS IN THE BASE. IN THE POINT OF GRAVITATIONAL CONTACT
STRUCTURE OF THE PIECE IS SUPPORTED. WHEN THE SPECTATOR WALKS AROUND
THREE DIMENSIONAL HIS VISION OF IT KEEPS CHANGING, BUT THE GRAVITATIONAL POINT
AS THE SPECTATOR MOVES, HE MAKES THE SCULPTURE MOVE. THE BASE
REMAINS IMMOBILE. WHAT HAPPENS IF WE EXCLUDE THE BASE? WHAT HAPPENS IF WE OPEN
PLACE IT AROUND US? WHAT HAPPENS IF WE MOVE
WITHOUT A BASE? (THE CENTER EVERYWHERE, THE CIRCUMFERENCE NOWHERE.
IS THE DESERT.) THE GRAVITATIONAL CENTER OF A ~~IMMEASURABLE~~ SCULPTURE
COMPLETELY OPEN AND WITHOUT A BASE IS US. THAT THE
WE ARE INSIDE AND OUTSIDE AT THE SAME TIME. AND THE
ARE SUSTAINED BY OUR GAZE AND OUR CONSCIOUSNESS

ESPECTADOR ESPECTANTE—OBJETO ESPECTANTE.
CON ESPECTATIVAS.
SUJETO QUE ESPERA + OBJETO QUE ESPERA = NO PASA NADA. EL ESPECTADOR EMPIEZA INTENTANDO ACTIVAR LA PIEZA.
RESPONDE CON INDIFERENCIA. PERO ALGO ESTA PASANDO: EL EVENTO SE ESTA MOVIENDO. HAY
EN EL CUAL NADA ("APARENTEMENTE") ESTA SUCEDIENDO.

IS THE VANISHING POINT.
THE VANISHING POINT IS IN THE BASE. IN THE POINT OF GRAVITATIONAL CONTACT WHERE RESTS
THE STRUCTURE OF THE PIECE. WHEN THE SPECTATOR WALKS AROUND AN OBJECT
HIS VISION OF IT KEEPS CHANGING, BUT THE GRAVITATIONAL POINT REMAINS IMMOBILE.
MOVES, HE MAKES THE SCULPTURE MOVE. THE BASE (LIKE A CLOCK)
IMMOBILE. WHAT HAPPENS IF WE EXCLUDE THE BASE? WHAT HAPPENS IF WE OPEN THE SCULPTURE AND
AROUND US? WHAT HAPPENS IF WE MOVE INSIDE A SCULPTURE
(THE CENTER EVERYWHERE, THE CIRCUMFERENCE NOWHERE. THE PERFECT LABYRINTH
DESERT.) THE GRAVITATIONAL CENTER OF A ~~IMMEASURABLE~~ SCULPTURE ~~WITHOUT A BASE~~
COMPLETELY OPEN AND WITHOUT A BASE IS US. WE MOVE THROUGH EVERY PART OF IT.
INSIDE AND OUTSIDE AT THE SAME TIME. AND THE LIMITS OF SPACE
SUSTAINED BY OUR GAZE AND OUR CONSCIOUSNESS (THERE WILL ALWAYS BE A CAP OF
WE DO NOT SEE) (LIKE THE WAKE AFTER THE ACTION).
BETWEEN THE

¿QUE PASA SI EXCLUIMOS LA BASE? ¿QUE
QUEDA INMOVIL. PASA SI NOS
LA UBICAMOS A NUESTRO ALREDEDOR? QUE PASA SI NOS
SIN BASE? (EL CENTRO EN TODAS PARTES, LA CIRCUNFERENCIA
ES EL DESIERTO). EL CENTRO GRAVITACIONAL DE UNA ESCULTURA
COMPLETAMENTE ABIERTA Y SIN BASE SOMOS NOSOTROS.
ESTAMOS EN EL INTERIOR Y EN EL EXTERIOR AL MISMO TI
ESTÁN SOSTENIDOS POR NUESTRA MIRADA Y NUESTRA CONDEN...
RESPIRAN QUE NO VEMOS (COMO LA ESTELA DESPUÉS DE LA AC
INTERACCIÓN ENTRE EL
HORIZONTE, FIRMAMENTO VISUAL Y
LA COLUMNA VERTEBRAL COMO PUNTO GRAVITACIONAL.

REMAINS IMMOBILE. WHAT HAPPENS IF WE EXCLUDE THE BASE? WHAT
WE PLACE IT AROUND US? WHAT HAPPENS IF WE
WITHOUT A BASE? (THE CENTER EVERYWHERE, THE CIRCUMFERENCE
IS THE DESERT.) THE GRAVITATIONAL CENTER OF A SCULPTURE
COMPLETELY OPEN AND WITHOUT A BASE IS US.
WE ARE INSIDE AND OUTSIDE AT THE SAME TIME
THEY ARE SUSTAINED BY OUR GAZE AND OUR CONSCIOUSNESS
YOGURT THAT WE DO NOT SEE) (LIKE THE WAKE AFTER THE ACTION
INTERACTION BETWEEN THE
HORIZON, VISUAL FIRMAMENT AND
THE SPINAL COLUMN AS GRAVITATIONAL POINT.

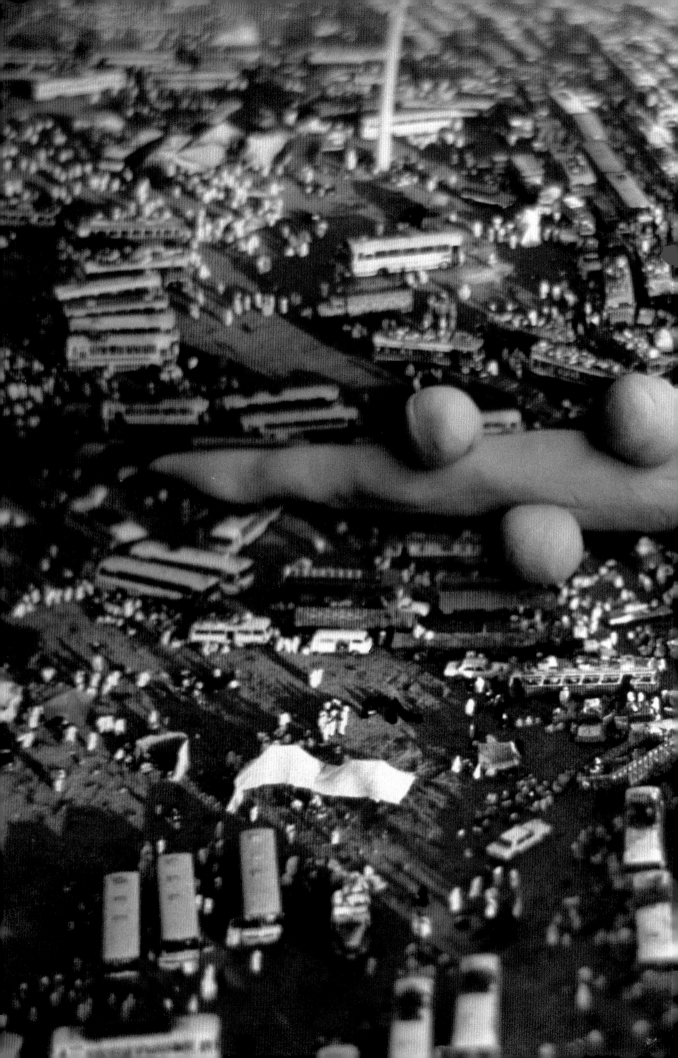

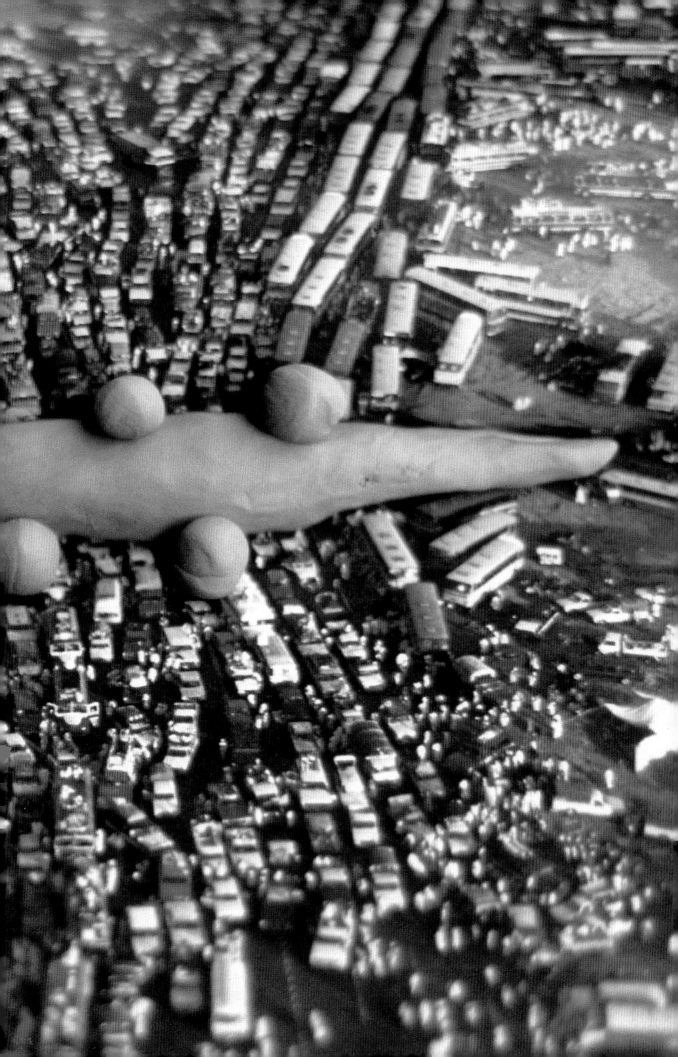

... un glosario de las principales figuras tradicionales de la poesía de Is-
landia en el que se lee por ejemplo, que gaviota del odio, significan
halcón de la sangre, cisne sangriento o cisne rojo, significan
el cuervo, y techo de ballena o cadena de islas, el mar,
y la casa de los dientes, la boca.

del siglo trece

A GLOSSARY OF TRADITIONAL FIGURES FROM THE POETRY OF ICE-
LAND IN WHICH WE CAN READ, FOR EXAMPLE, THAT SEAGULL OF HATRED,
FALCON OF BLOOD, BLOODY SWAN OR RED SWAN, SIGNIFY
THE RAVEN; AND ROOF OF WHALE OR CHAIN OF ISLANDS. THE SEA,
AND THE HOUSE OF THE TEETH, THE MOUTH.

```
R  O  N  Q      S  I  N  A
O  R  N  I      E  S  A  C
R  I  O  L      L  L  L  I
A  P  T  A      V  P  S
L  E            E  O
                E  S  M
```

SELVEE OF WHALES SELVEE NALS QUILA

 ROOF OF THE WHALES

ROOF OF

WHALES

DIARIO	AZUL

CALCOMANÍAS EN EL TECHO

ALMA DE CALCOMANÍA

DIARIO AZUL.

CASA PARA PELÍCULA

MATEMÁTICAS FOTOGRÁFICAS

BLUE
DIARY

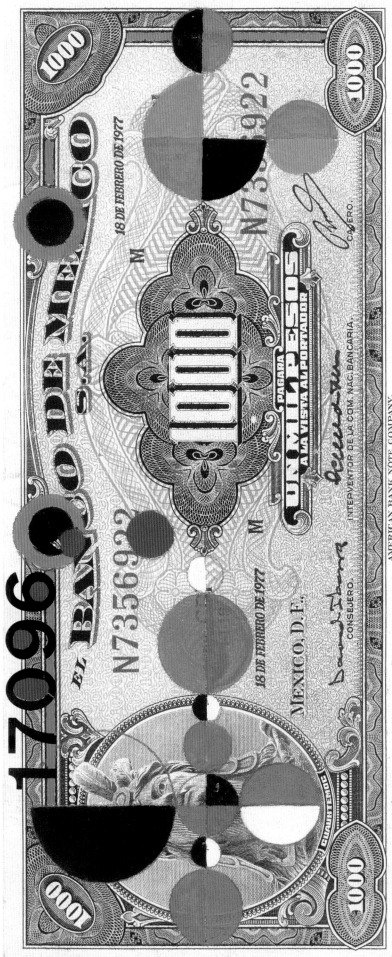

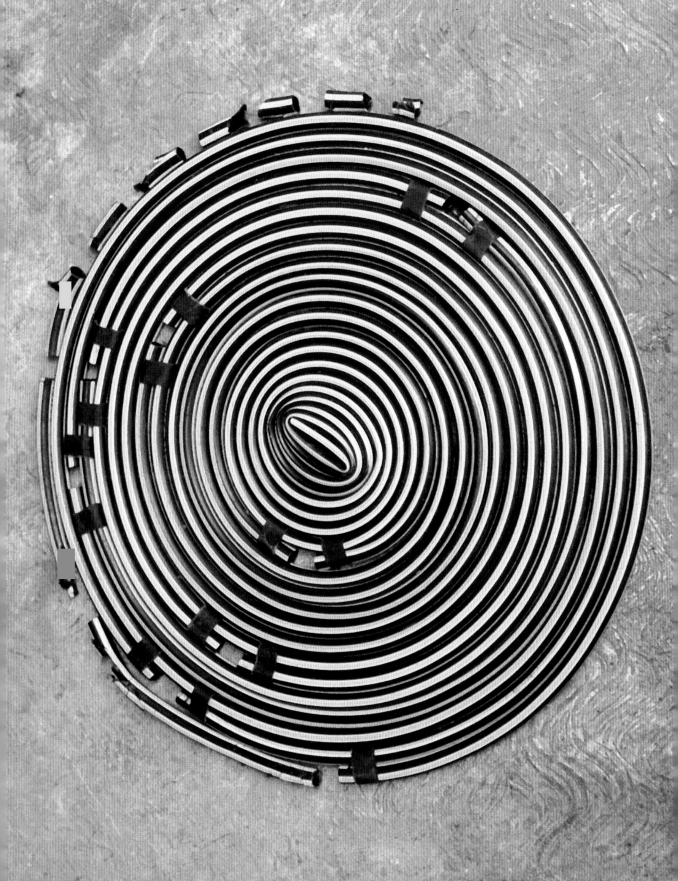

...vi fútbol.

CAMPO DE SÁBANAS BLANCA...

SUEÑO DE PASTO VERDE...

LINEAS BLANCAS. POLLO

BALON ANTIGUO.

- PELICULA PORTEROS. 2u...

FÚT-BOL ENTRE DOS ALM...

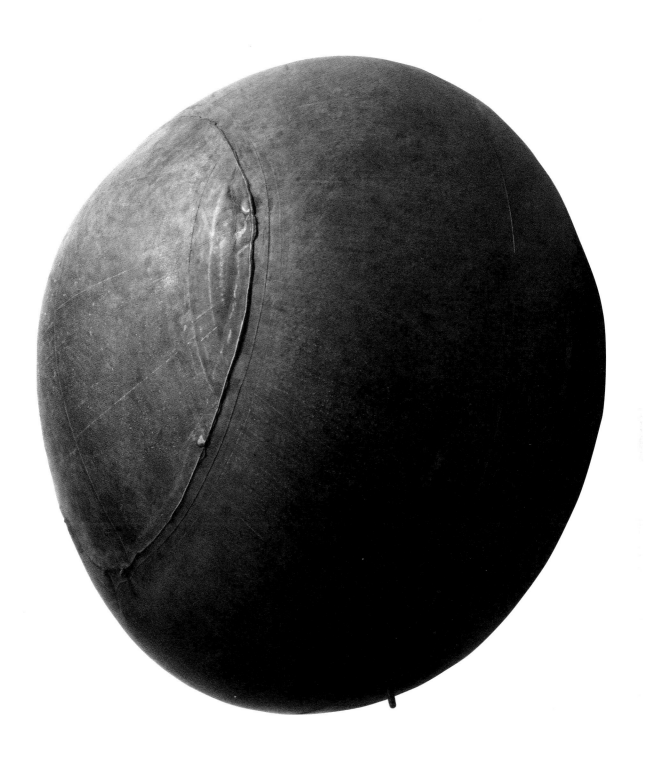

FIELD OF WHITE SHEETS

DREAM OF GREEN PASTURES

WHITE LINES. DUST

ANCIENT BALL.

FILM GOALIES.

SOCCER BETWEEN TWO

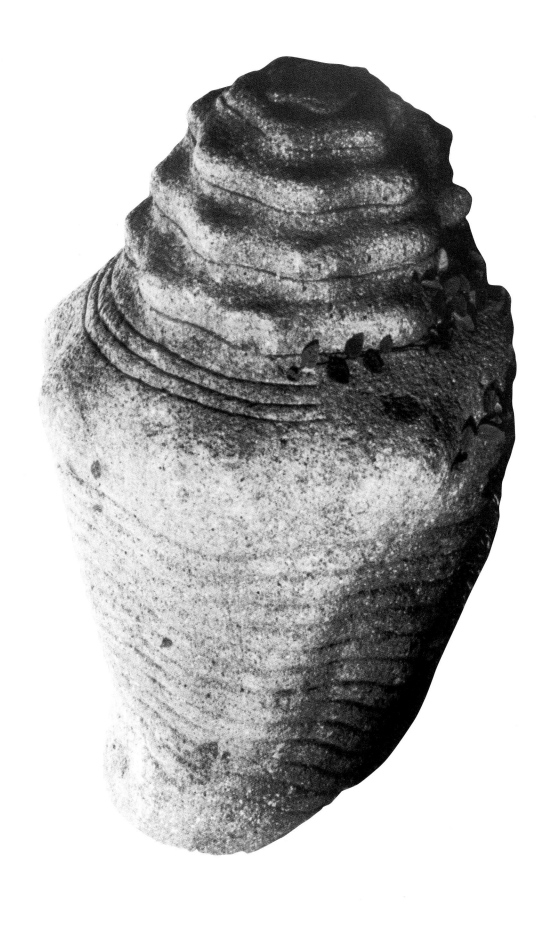

- I AIM TO PROVE THAT PERSONALITY) IS A CHIMERA SUSTAINED BY HABIT AND CONCEIT, WITH NEITHER METAPHYSICAL SUPPORT NOR INTRINSIC REALITY. THEREFORE, I WANT TO SUBJECT LITERATURE TO THE CONSEQUENCES FLOWING FROM THOSE PREMISES. I WISH TO ELABORATE AN AESTHETIC PRINCIPLE THAT WILL OPPOSE THE PSYCHOLOGISM LEFT TO US BY THE LAST CENTURY.

 THERE IS NO SUCH A THING AS AN "I" CAPABLE OF SUSTAINING ITS UNITY.

→ SITUATION IS THE ORGANIZATION OF A NARRATIVE SEQUENCE. LATER ON, BORGES WILL REPLACE SITUATION WITH ANOTHER TERM, PLOT. ALREADY A FAVORITE TO STEVENSON, PLOT IS FOR BORGES WHAT SIUZHET WAS FOR THE RUSSIAN FORMALISTS, THAT IS, A STRUCTURALLY MEANINGFUL ORGANIZATION OF ELEMENTS. IT SHOULD BE MADE CLEAR, HOWEVER, THAT IN BORGES'S STORIES SITUATION MAY COINCIDE TOTALLY WITH THE PLOT, OR MAY COINCIDE PARTIALLY. WITH JUST ONE OF THE DIFFERENT LEVELS THAT CUMULATIVELY CONSTITUTE THAT PLOT. BEARING THIS IN MIND, ONE MIGHT SAY THAT, IN BORGES'S FICTION CHARACTER AND SITUATION ROUTINELY COINCIDE. OR RATHER, ONE MAY SAY THAT THE DISSOLUTION OF THE

"MI OBJETIVO ES PROBAR QUE LA PERSONALIDAD ES UNA QUIMERA SOSTENIDA POR EL HABITO Y LA PRESUNCION, SIN SOSTEN METAFISICO NI REALIDAD INTRINSECA. ENTONCES, QUIERO SOMETER LA LITERATURA A LAS CONSECUENCIAS QUE BROTAN DE ESAS PREMISAS. EN BASE A ESAS PREMISAS, QUIERO ELABORAR UN PRINCIPIO ESTETICO QUE SE OPONDRIA AL PSICOLOGISMO QUE NOS HA DEJADO EL ULTIMO SIGLO."

NO HAY COSA ALGUNA COMO UN "YO" CAPAZ DE SOSTENER SU UNIDAD.

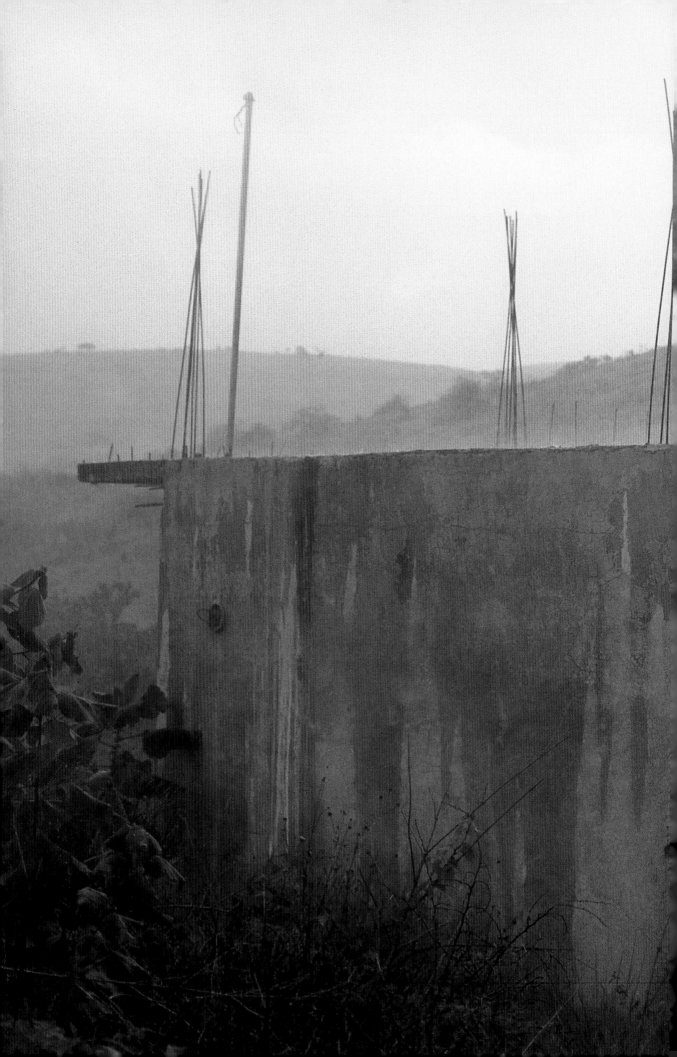

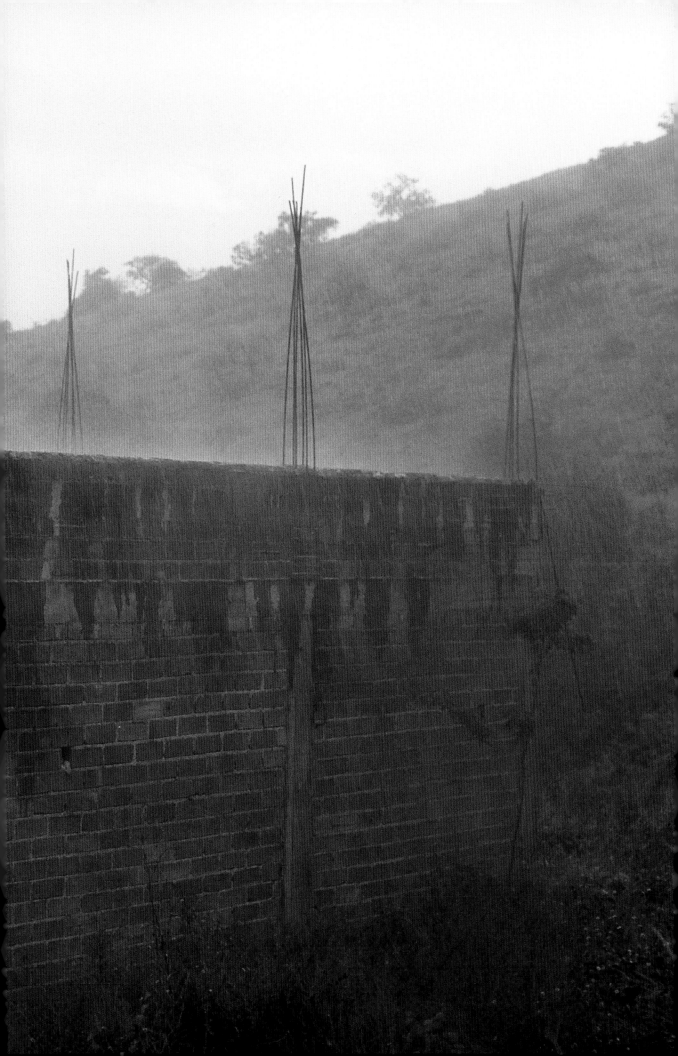

LANZAR LA TRANSFERENCIA EN MOVIMIENTO.

CUADRAR LOS BRAZOS HAY MUCHO
TERCERO DE RESERVA

REPUBLICA
... DEPORTIVA, CHILE.
... PARQUERO ...
... SUCESIVO
... PUNTOS PUNTOS.
+

. PUNTOS DE REPOSO + PUNTOS DE REPOSO + PUNTO DE REPOSO.
. LAS COSAS NO FLOTAN.
LA FRICCION LAS DETIENE EN MOVIMIENTO
FLOTAR ES VARIOS MOVIMIENTOS EN DIVERSAS DIRECCIONES IMPRECISOS.
FLOTAR ES NO DECIDIR DECIDIENDO PERMANECER EN MOVIMIENTO.
PLANETAS.
CIRCULAR. ESTRELLAR: SON FORMAS DE PERMANECER EN PERMANECER EN EL ESPACIO
SIN LLEGAR NUNCA A LOS LÍMITES DE LA ESFERA.
EL CENTRO EN TODAS PARTES. LA CIRCUNFERENCIA

RESTING POINT + RESTING POINT + RESTING POINT.
THINGS DO NOT FLOAT.
FRICTION KEEPS THEM IN MOTION
FLOATING IS VARIOUS MOVEMENTS IN DIVERSE INDECISIVE DIRECTIONS.
FLOATING IS NOT DECIDING DECIDING TO STAY IN MOVEMENT.
PLANETS.
CIRCLING, SHATTERING: THESE ARE WAYS TO DISAPPEAR INTO SPACE
WITHOUT EVER REACHING THE LIMITS OF THE SPHERE.
THE CENTER EVERYWHERE. THE CIRCUMFERENCE NOWHERE.

GLOBOS ENTRE COCHES

GLOBO

coche @ coche

☐ ☐

☐ ☐

BALLOON BETWEEN CARS

CAR BALLOON CAR

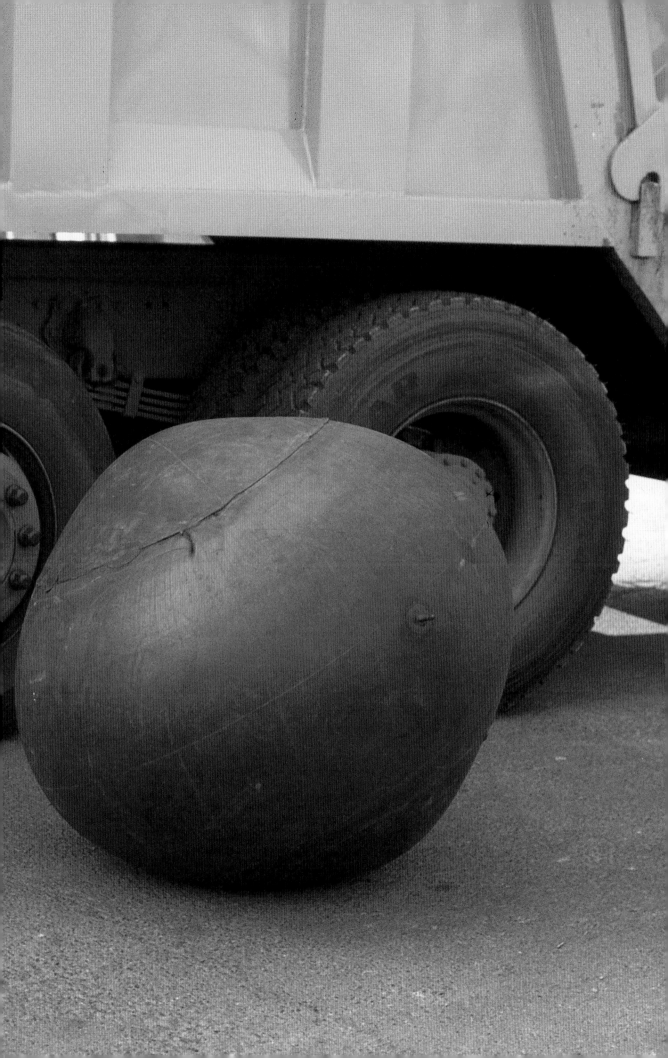

THE "REALITY" (WHITE BACKGROUND SURFACE, THE OPEN SPACE IN WICH OBJECTS CAN APPEAR) OBTAINS ITS CONSISTENCY ONLY BY MEANS OF THE "BLACK HOLE" IN ITS CENTER (THE LACANIAN .DAS DING: THE THING THAT GIVES BODY TO THE SUBSTANCE OF ENJOYMENT) I.E. BY THE EXCLUSION OF THE REAL, BY THE CHANGE OF THE STATUS OF THE REAL INTO THAT OF A CENTRAL LACK. P. 19 Ṣ̌ẈẠ̣J ŽIŽEK LOOKING AWRY.

SLAVOJ ŽIŽEK

THE PRIMAL JOKE. P. 18 - IBIDEM.

LA "REALIDAD" (SUPERFICIE BLANCA AL FONDO, LA "NADA LIBERADA," EL ESPACIO ABIERTO EN
QUE LOS OBJETOS PUEDEN APARECER) OBTIENE SU CONSISTENCIA SOLO A TRAVES DEL "HOYO NEGRO"
EN SU CENTRO (EL "DAS DING" LACANIANO, AQUELLO QUE LE DA CUERPO A LA SUSTANCIA
DEL GOCE) POR EJEMPLO, POR LA EXCLUSION DE LO REAL, POR EL CAMBIO EN EL
ESTADO DE LO REAL HACIA AQUELLO DE UN <u>VACIO CENTRAL</u>. P. 19 SLAVOJ ZIZEK
 LOOKING AWRY

LA BROMA PRIMERA. P. 18. IBIDEM.

-TRABAJO "DESINTERESADO": TEJER, JUGAR AJEDREZ, MANEJAR UN TAXI. OBJETIVOS A CORTO PLAZO. RELACION DE TIEMPO - ESPACIO-PERSONA DEDICADA AL DIA 4 A 10 QUE TIENE DE INMEDIATO- CONSTRUIR UNA CASA PARA CONSTRUIR UNA CASA (SCHWITTERS). HACER UN MUSEO PARA TENER UNA OFICINA (BROODTHAERS). FORMAR UNA FABRICA PARA PRODUCIR, HACER DINERO Y COMPRAR COSAS (WARHOL). PARTIDO POLITICO PARA SEMBRAR ARBOLES (BEUYS). JUGAR AL AJEDREZ. LEER (BORGES). JUGAR AL AJEDREZ. AL BILLAR. JUGAR AL PAISAJE (MONDRIAN). JUGAR AL TORO (PICASSO). JUGAR AL NAVEGANTE. AL EMPRESARIO, AL BUROCRATA, AL TURISTA. AL DISEÑADOR. VER. P 54

"DISINTERESTED" WORK: KNITTING, PLAYING CHESS, DRIVING A TAXI. SHORT TERM OBJECTIVES.
A TIME-SPACE-PERSON RELATION DEDICATED TO THE DAY AND TO THAT WHICH
IS IMMEDIATE. TO CONSTRUCT A HOUSE JUST TO CONSTRUCT A HOUSE (SCHWITTERS).TO MAKE A
MUSEUM JUST TO HAVE AN OFFICE (BROODTHAERS). TO FORM A FACTORY TO PRODUCE
MONEY AND BUY THINGS (WARHOL). A POLITICAL PARTY FOR PLANTING TREES
(BEUYS). TO PLAY CHESS. TO READ (BORGES). TO PLAY CHESS. BILLIARDS.
TO PLAY THE LANDSCAPE (MONDRIAN). TO PLAY THE BULL (PICASSO). TO PLAY THE SAILOR.
THE BUSINESSMAN, THE BUREAUCRAT, THE TOURIST. THE DESIGNER. VER. P 54

UN ZAPATO

DOS ZAPATOS

UNA SEMILLA

DOS SEMILLAS

FRUTAS

NAVES

MEDIOS DE TRANSPORTE

ONE SHOE

TWO SHOES

ONE SEED

TWO SEEDS

FRUITS

SHIPS

MEANS OF TRANSPORTATION

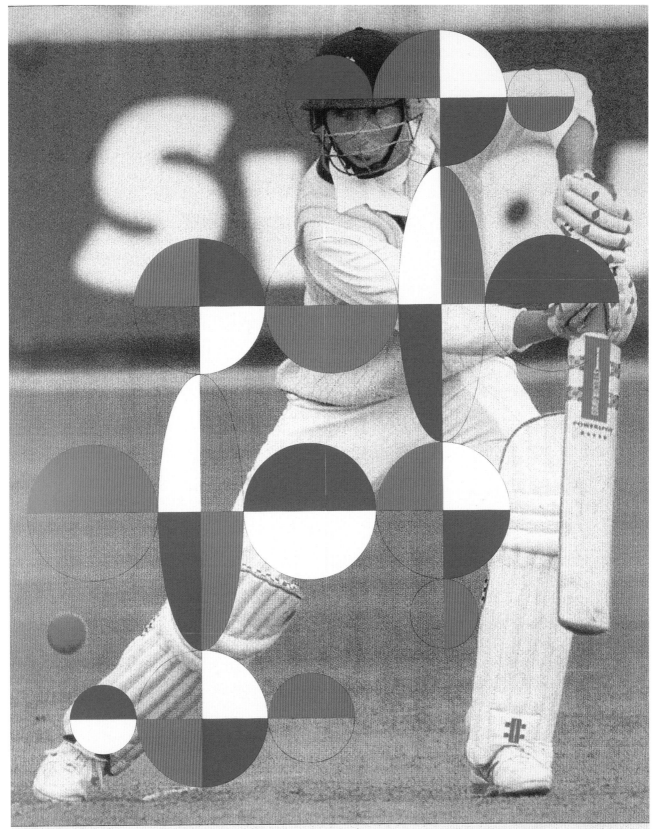

Atherton steers the ball into the off side during his unbeaten innings of 121 at Old Trafford yesterday

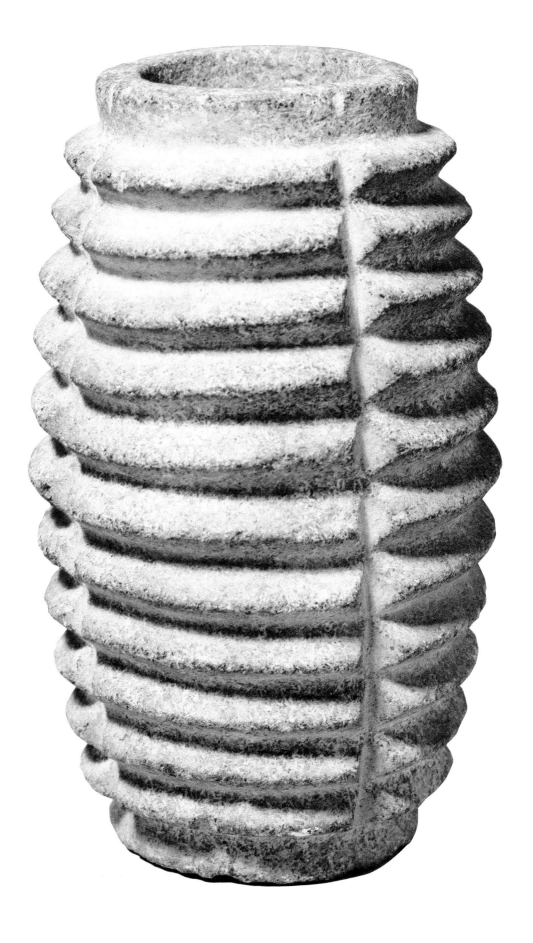

... lo que sucedió en el m...

acciona situadora técnica individual inconsciente

trabajo del I. inc.

tenciar.

ACTION
SITUATING
LUMINOUS
INDIVIDUAL
CONSCIOUS

WORK OF THE IND. E.
TO WITNESS.

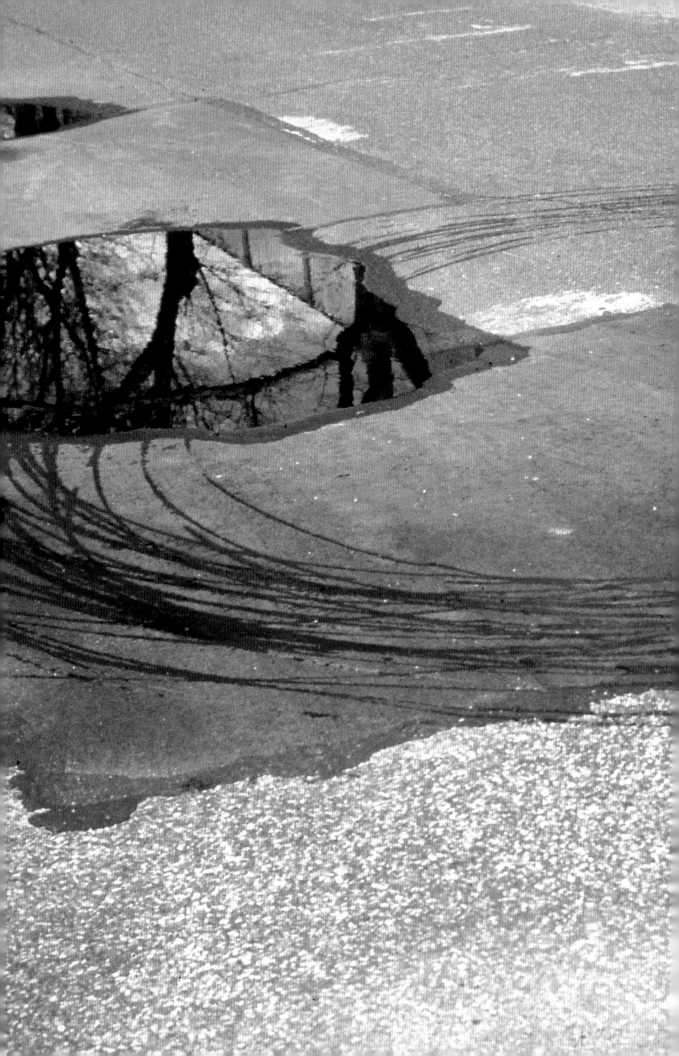

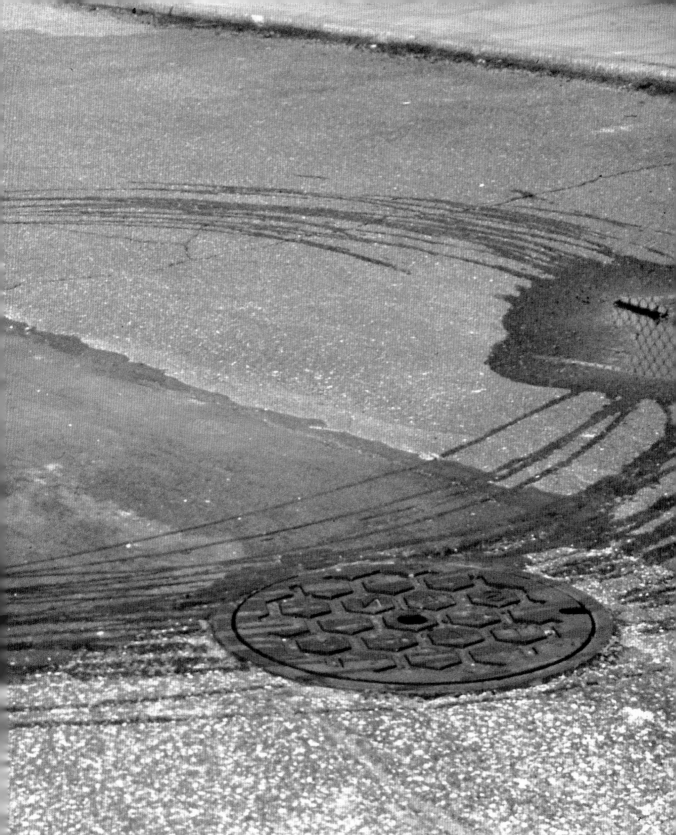

LO QUE SEA ES LO QUE SEA ES

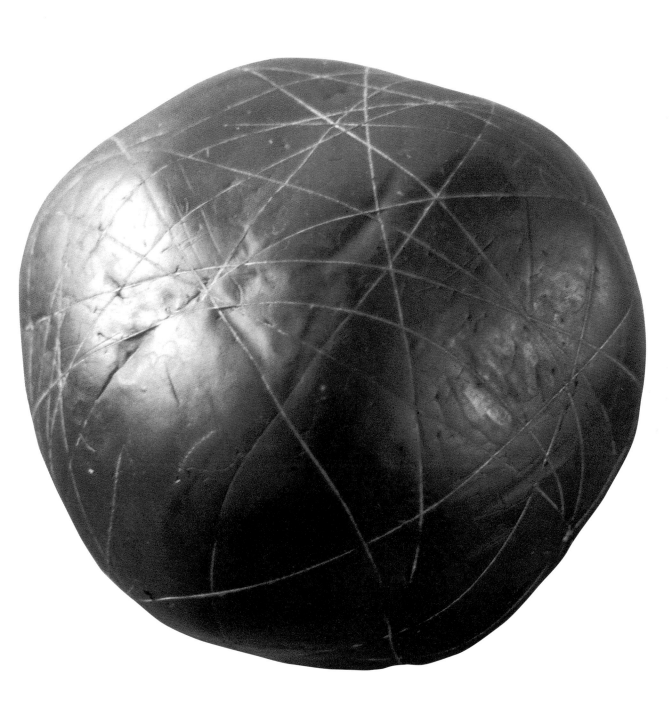

IT IS IS WHAT IT IS IS WHAT IT IS IS WHAT IT IS IS WHAT IT IS IS WHAT IT IS IS WHAT IT IS IS WHAT

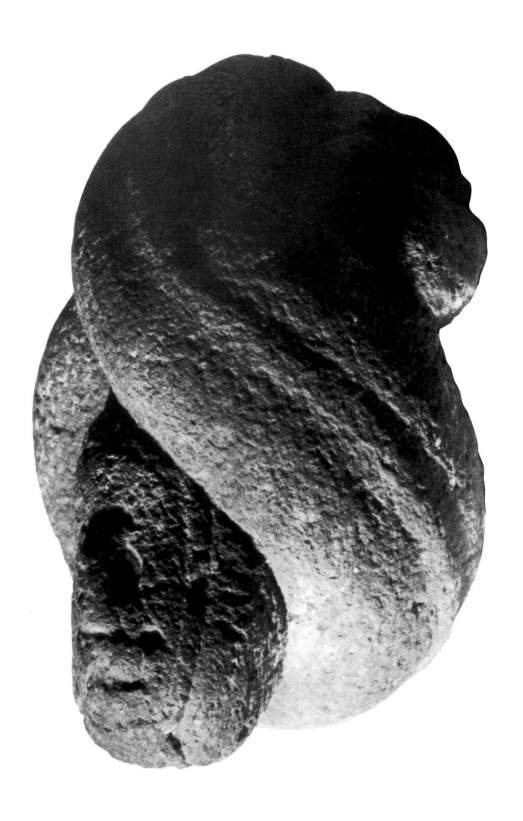

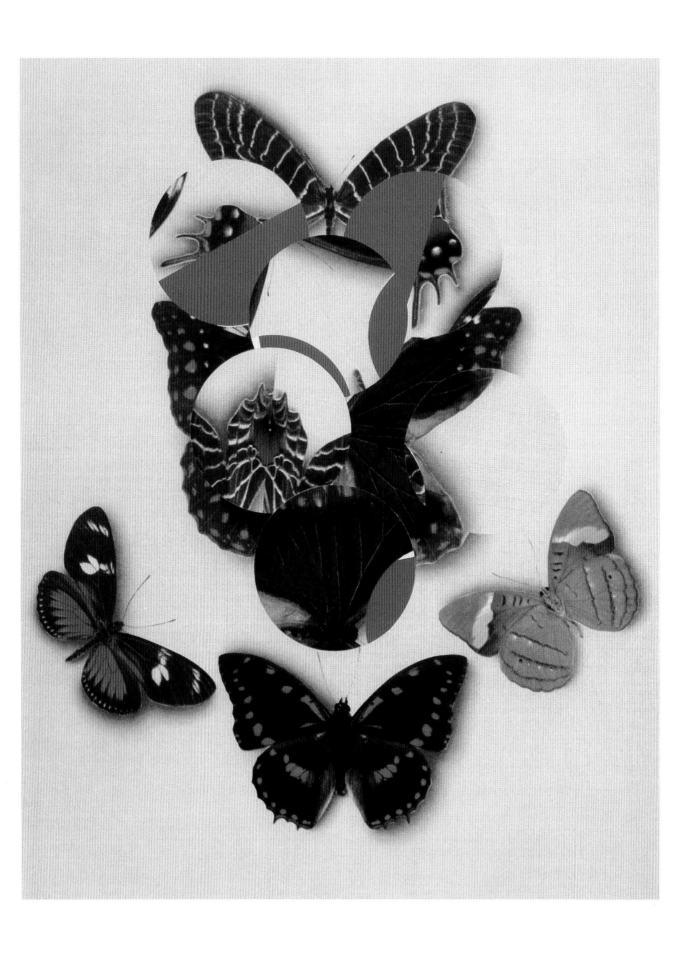

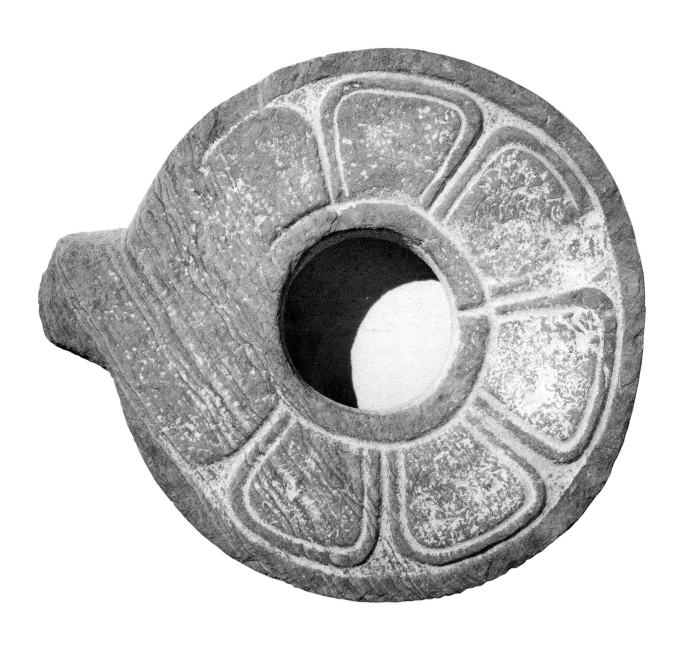

ENTRE LA BASE Y
LA ESCULTURA

LA FOTOGRAFÍA
COMO UN HONGO

LA ESCULTURA COMO
UNA FRUTA

ACCI...
UN
PAR...
CUENTA

BAIL...
SIGUIE...
ROJO.
ESCLV...

PLASTILINA
EXTENDIDA EN EL SUELO.
VOLTEAR,
ABAJO SUCEDE LO QUE SUCEDE

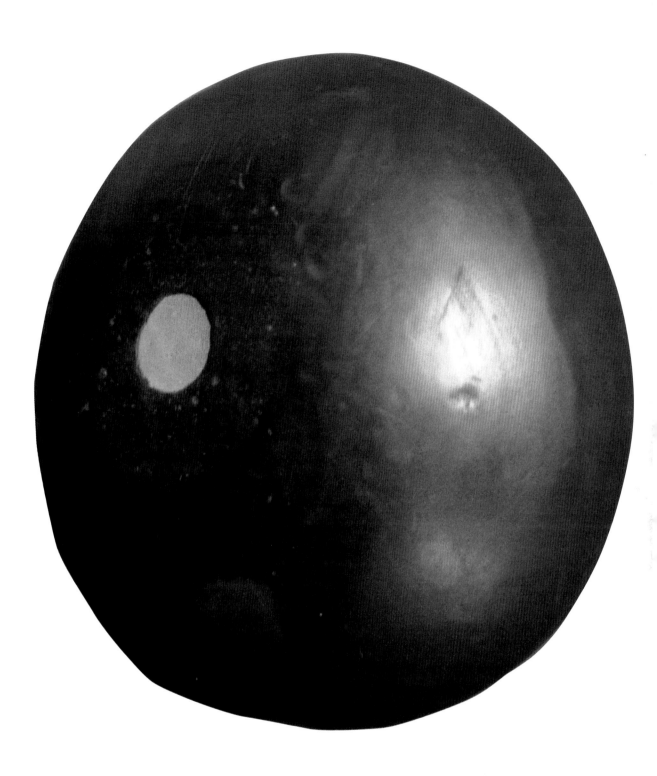

SCULPTURE AS
A FRUIT

PLASTICINE
SPREAD OUT ON THE GROUND.
TURN AROUND.
BELOW IS HAPPENING WHAT IS HAPPENING

PHOTOGRAPHY
AS A HOLE

BETWEEN THE BASE
AND THE SCULPTURE

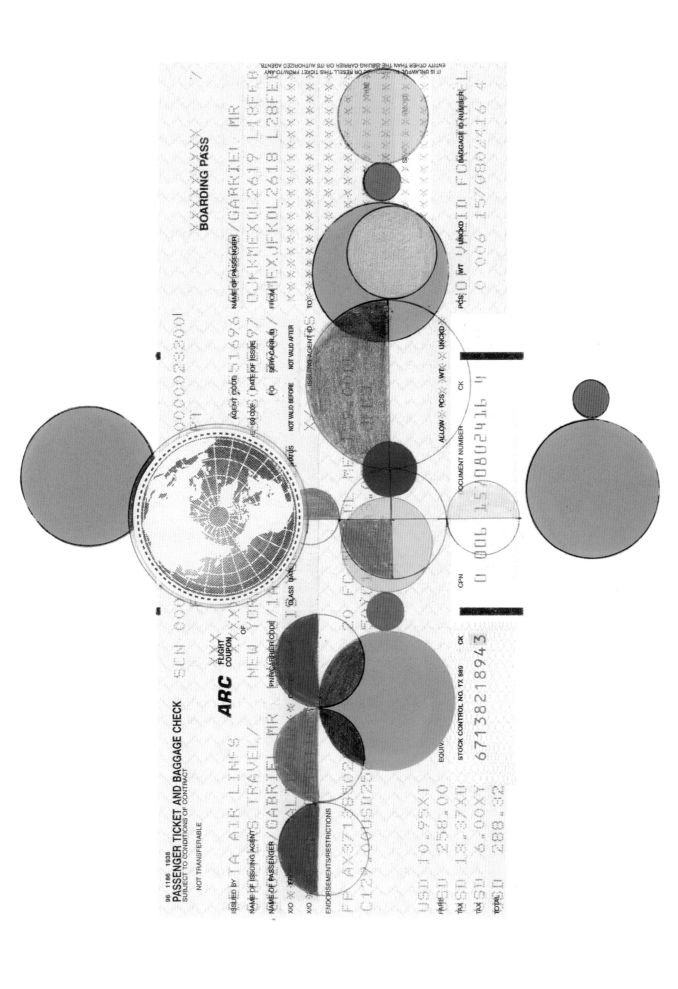

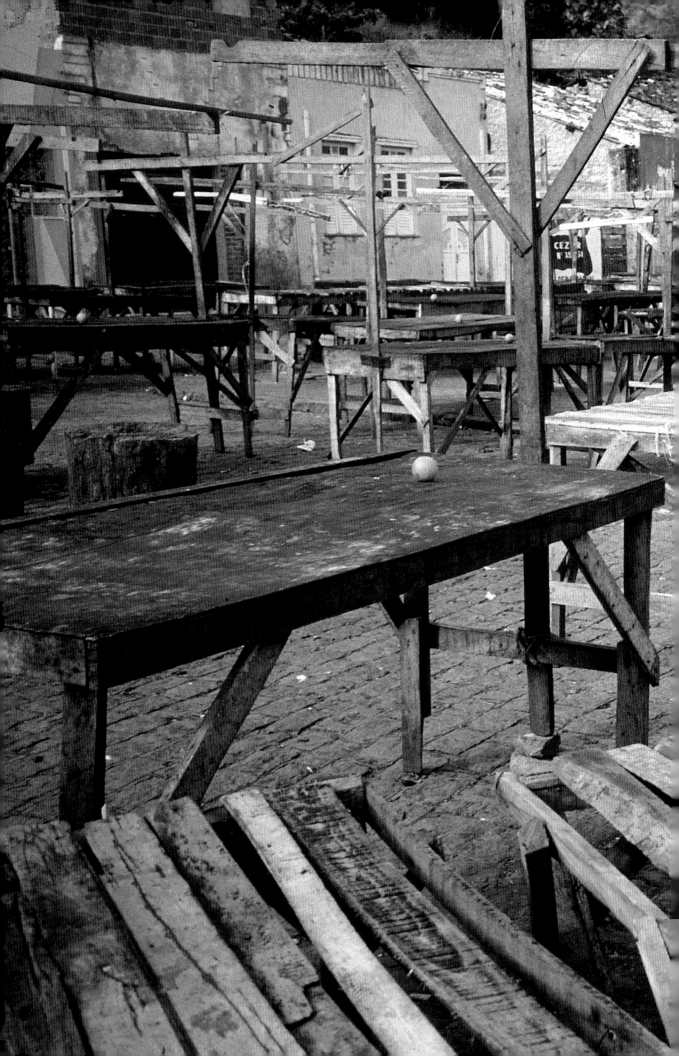

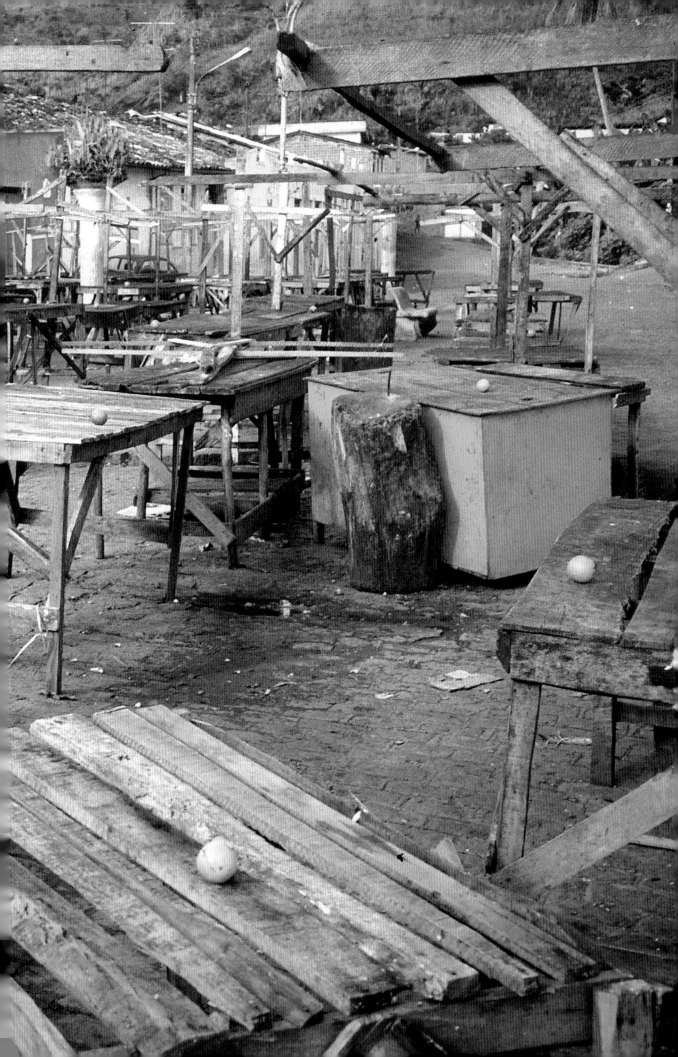

27 V 93

HELICÓPTERO CON HÉLICE DE ALCACHOFA.

ICA:

ESCUPIDA
EN MURO BLANCO
EXPANDIDA CON
LOS DEDOS

(98)

27 V 93

HELICOPTER WITH AN ARTICHOKE PROPELLER.

ICA:

SPIT
ON THE WHITE WALL
SPREAD OUT WITH
THE FINGERS

LO INTERNO.

EL GRUESO DE LA PIEL. EL FILO DE LA TAPA. (RECIPIENTE Y EXTERIOR).

OLLA. FRUTA. CÁSCARA. TAPA.

TAPA TRANSPARENTE.

LOS BORDES

VIDA NEGRA-

FOTOS COLUMNAS.

CORCHOLATA INCRUSTADA-

LOST LINE. (LÍNEA INCIDIENDO EN MACA (VULNERABLE).

CORTAR UNA NARANJA- GENERAR EL ESPACIO DEL FILO DEL CUCHILLO.

DIVIDIR Y EXPANDER EXTENDER EL ESPACIO INTERMEDIAIO.

PELOTA DE HULE LLENA DE AIRE

TODO LO OTRO

THE INTERNAL.
THICKNESS OF THE SKIN. THE SHARP EDGE OF THE CAP. (RECEPTACLE AND EXTERIOR.)
POT. FRUIT. RIND. CAP.
TRANSPARENT CAP.
THE BORDERS

BLACK STICK.
PHOTOS COLUMNS.
INCRUSTED CAP.
LINEA PERDIDA. (LINE INCISING IN A VULNERABLE MASS.)

TO CUT AN ORANGE. GENERATE THE SPACE OF THE EDGE OF THE KNIFE.
TO DIVIDE AND TO EXPAND. TO EXTEND THE SPACE IN BETWEEN.

RUBBER BALL FULL OF AIR

ALL THE REST

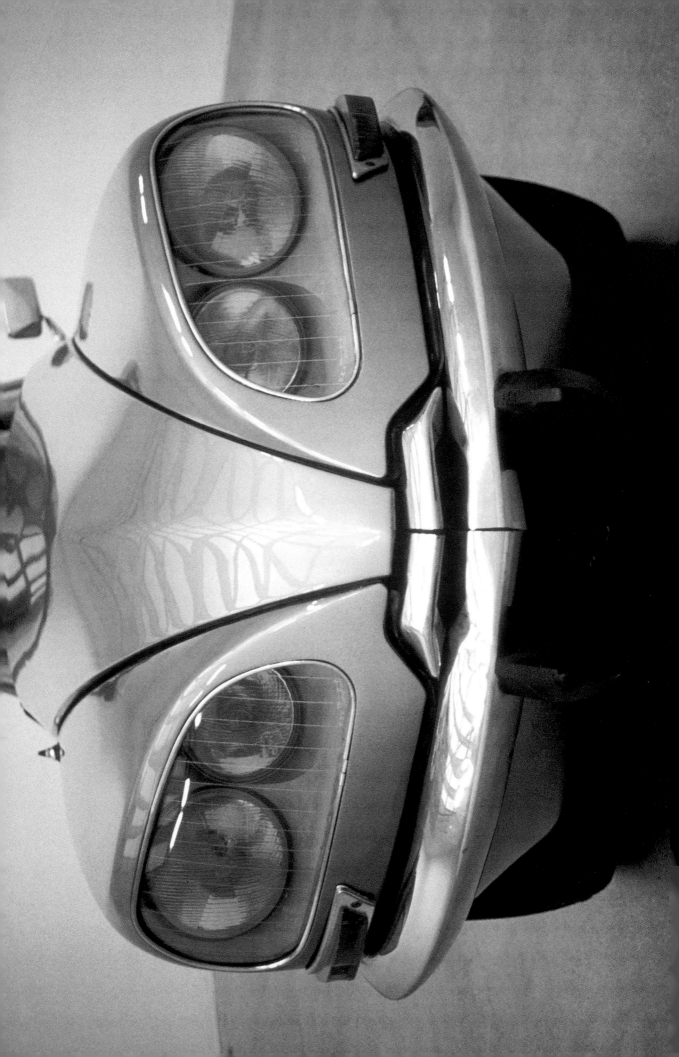

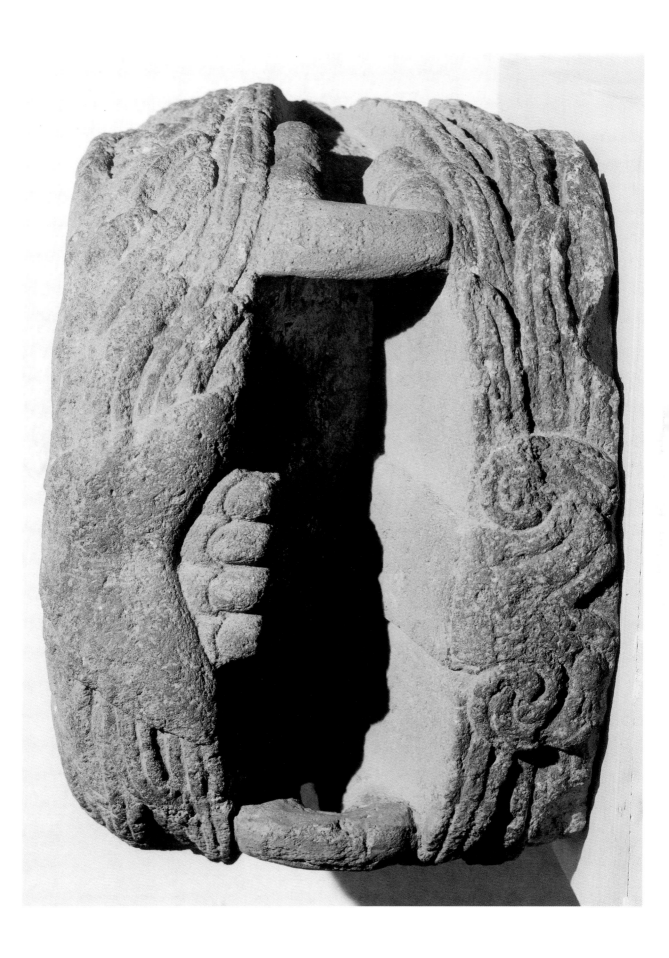

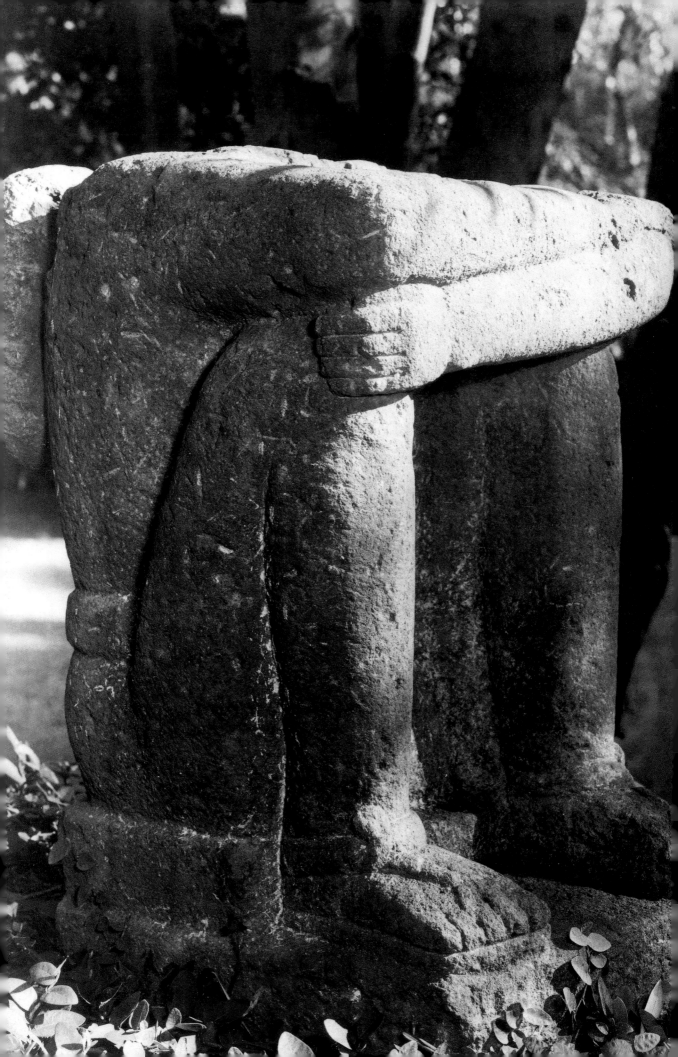

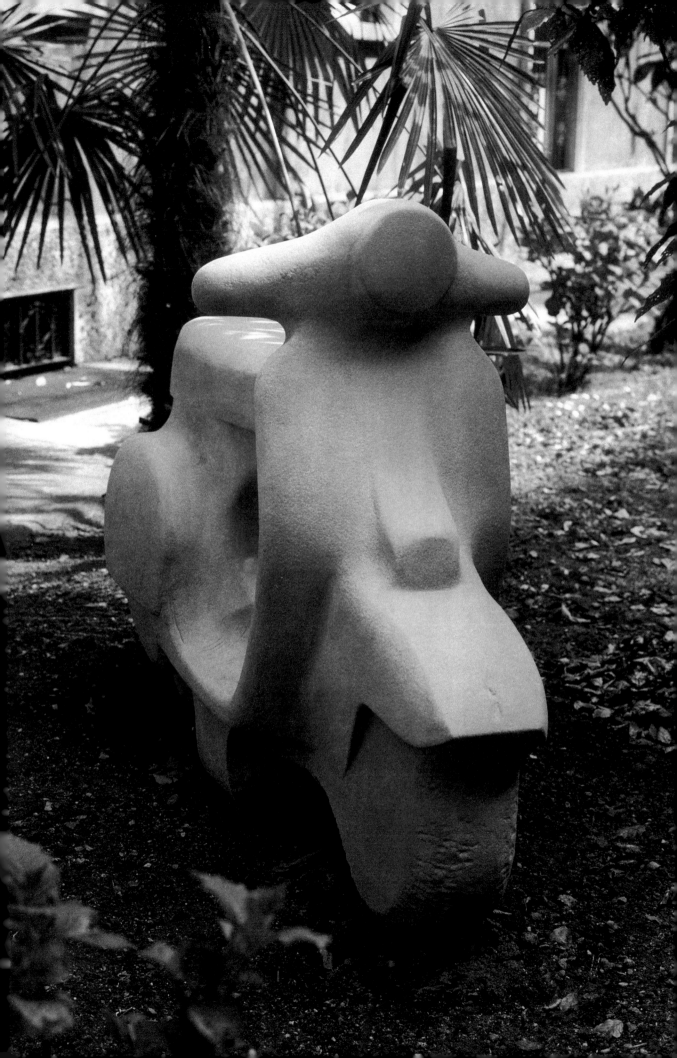

D CONSISTED OF ABSTRACT GEOMETRIC FORMS, OR "IDEAS"; PHYSICAL
REALITY, THE KEY TO UNDERSTANDING THE UNIVERSE LAY INT
ATHEVER)

PLATOS

FLÁTANOS

PLÁTANOS PLATÓNICOS

CONSISTIA DE FORMAS GEOMETRICAS ABSTRACTAS, O "IDEAS"; FISICA
REALIDAD. LA CLAVE PARA ENTENDER EL UNIVERSO ESTABA EN
CUALQUIERA)

PLATES

PLATONIC BANANAS

BANANAS

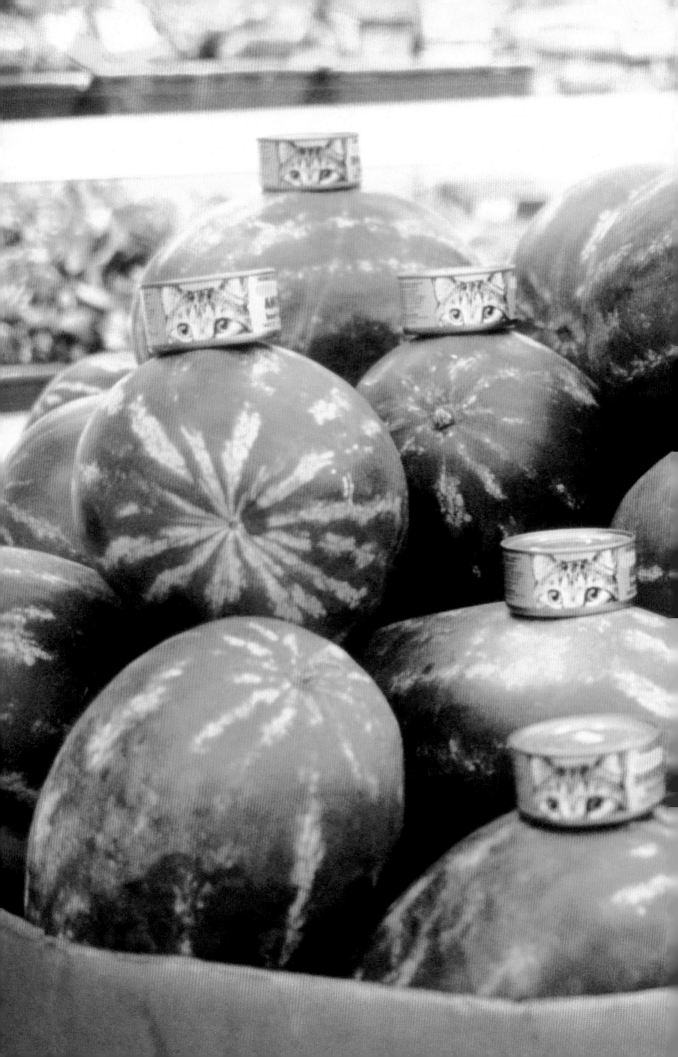

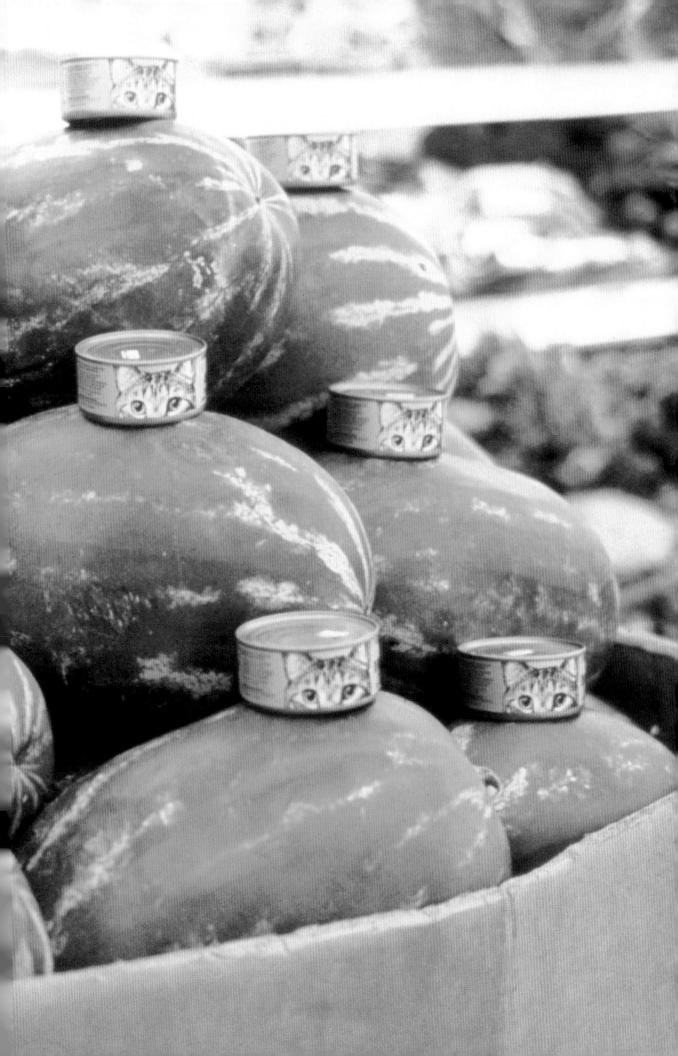

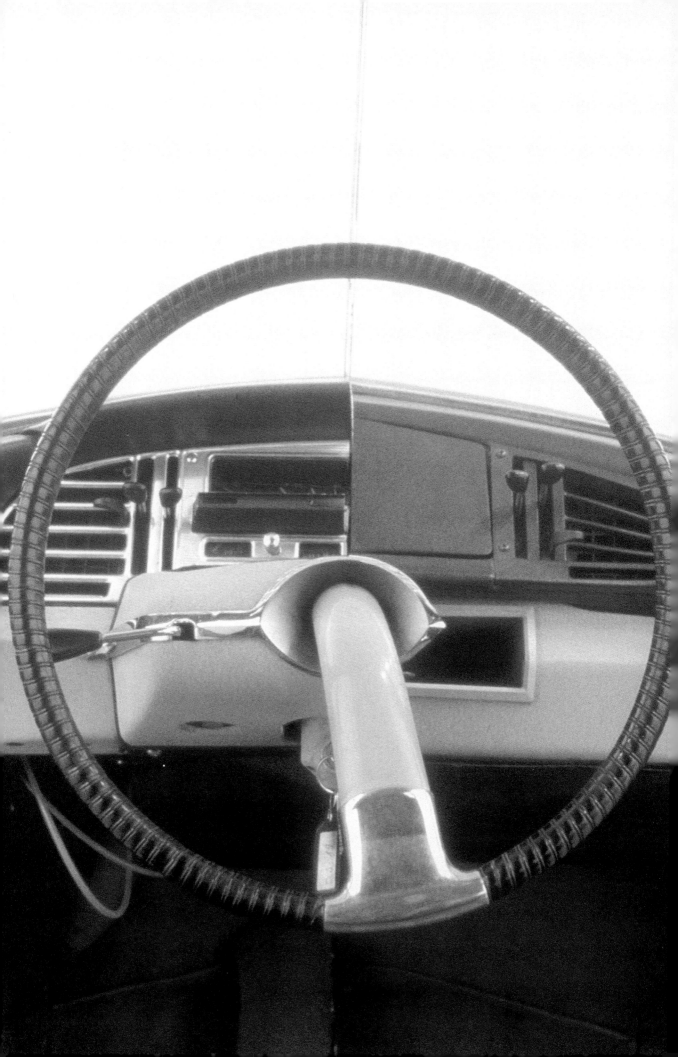

UNA HAMACA
UNA TAPA
UNA PIEDRA
UN COCHE
UNA ESCUPIDA

Y SE TERMINÓ EL AÑO.

ALGUNAS FOTOGRAFÍAS.
UN RELOJ HÚMEDO
VARIAS NARANJAS CORTADAS
UN SATÉLITE (CCCP)

UNA HAMACA UNA TAPA UNA CAJA
Y TODO LO QUE SUCEDIÓ A SU ALRED
UNA PIEDRA GRIS.

FUEGO B
UNA CAJA DE ZAPATOS
CON.
GO
CORE
TIEMPO
EMPO
VOLUN
LINEA
INFINIT
VEHICU
ESTELA

TRUCC YØ

G()

AD

DESCUIDA UN COCHE.
SR. INNOMBRABLE.

L
T I
CA

°

13 XII 93

A HAMMOCK
A CAP
A STONE
A CAR
SPIT

A SHOE BOX

AND THE YEAR IS OVER.

A FEW PHOTOGRAPHS.
A WET WATCH.
SEVERAL SLICED ORANGES
A SATELLITE (CCCP)

A HAMMOCK A CAP A BOX SPIT A CAR.
AND EVERYTHING THAT HAPPENED AROUND IT.
A GRAY STONE.

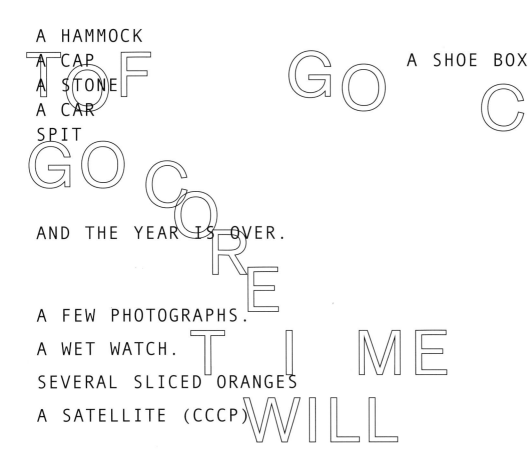

OF GO CON
GO CORE TIME WILL
LINE P
INFINITE
VEHICL
WAKE

TRUCT I

GO

O LI

INNUMERABLE.

TI

CS

E

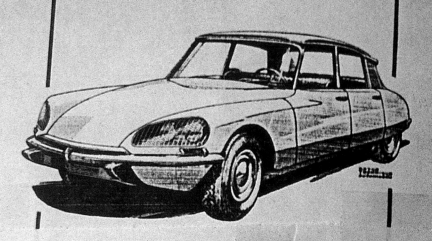

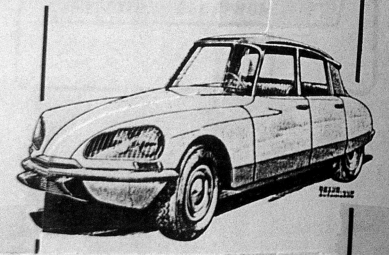

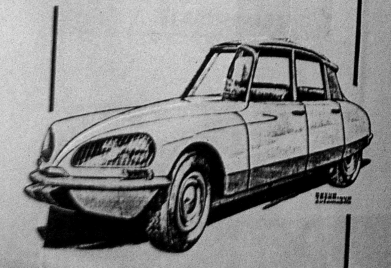

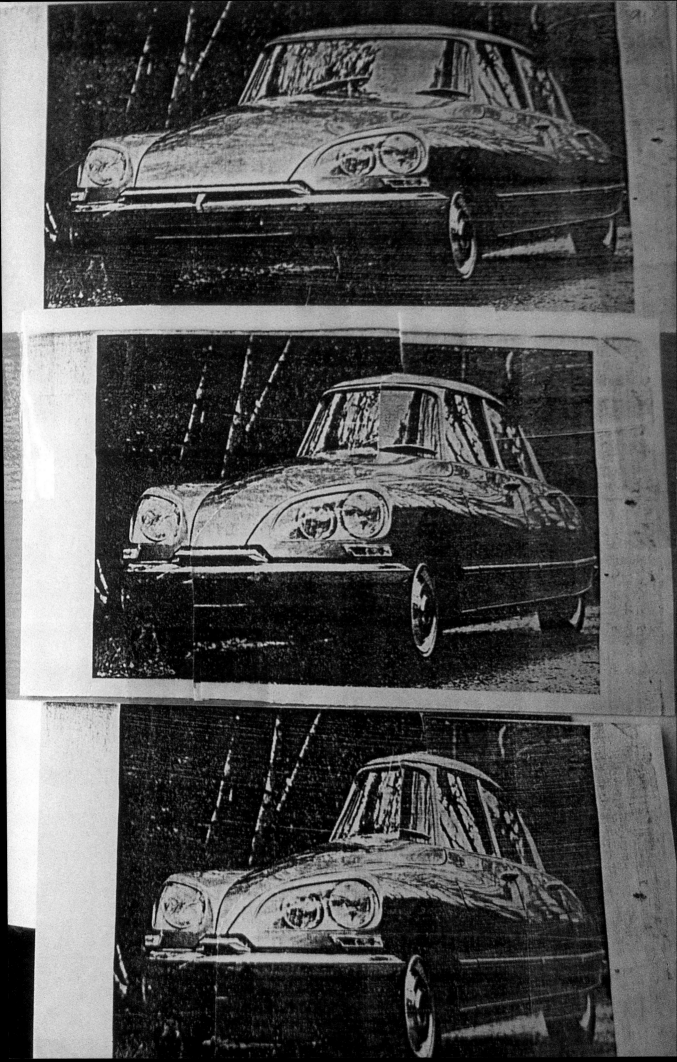

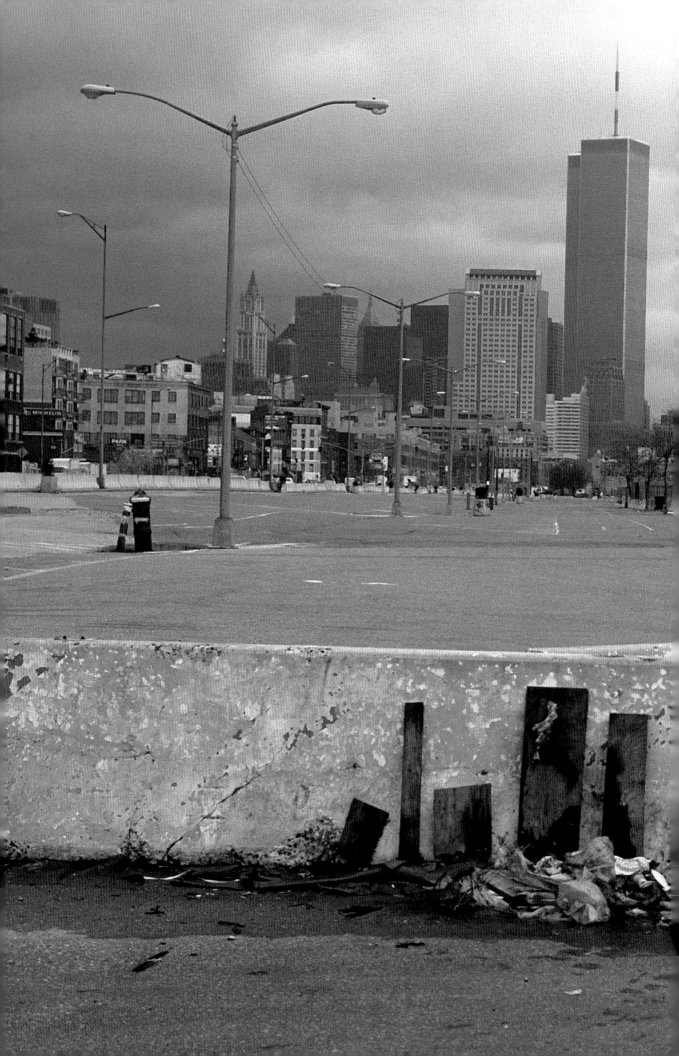

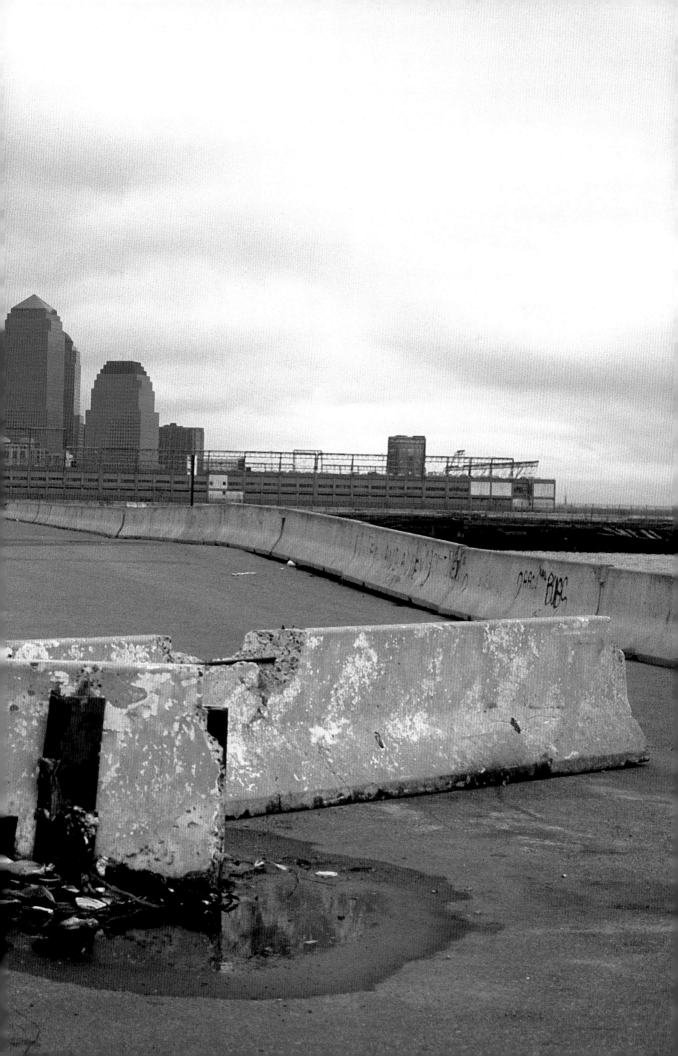

DS:

ILUSIÓN PERSPECTIVA TRIDIMENSIONAL. PERSPECTIVA Y TIEMPO.
ILUSIÓN COSA Y SU REFLEJO. PERFIL INTACTO CON AUSENCIA DE PROFUNDIDAD.
PERFIL PRIMER PLANO. SEGUNDO PLANO ACERCADO.
FRENTE. PUNTO CENTRAL. DIAGONALES Y FUGAS COFRE. FAROS, APENAS.
INSECTO. NAVE.
INTERIOR. VIAJE. HABITACIÓN. DESPLAZAMIENTO. LA MITAD DE LA MITAD
DE LA MITAD DE LA MITAD. HACIA MISMO.

EL INTERIOR DE UNA ESCULTURA. NO EN TÉRMINOS FÍSICAS. SINO EL
UN POSIBLE SISTEMA DE TENSIONES INTERNAS QUE (COMO ESTRUCTURA)
SOPORTA LA CORTEZA (O PIEL) DE UNA COSA O EVENTO.

EL ESPACIO 'VACÍO' ENTRE UNA ACCIÓN Y OTRA. ENTRE DOS MITADES.
EN EL CENTRO DE UNA UNIDAD EN MOVIMIENTO. INTRODUCIR UNA
NOCIÓN DE TIEMPO EN UN OBJETO QUE SE DESPLAZA GENERA UN
VACÍO. (UN ESPACIO) ESPECÍFICO DENTRO DE LA UNIDAD DEL OBJETO.
CON EL MOVIMIENTO DE UNA COSA ALGO SE PIERDE. UBICACIÓN

... SINO EN UN POSIBLE SISTEMA DE TENSIONES INTERNAS QUE (COMO ESTRUCTURA) SOPORTA LA CORTEZA (O PIEL) DE UNA COSA O EVENTO.

EL ESPACIO VACÍO - ENTRE UNA ACCIÓN Y OTRA. ENTRE DOS MITADES. EN EL CENTRO DE UNA UNIDAD EN MOVIMIENTO. INTRODUCIR UNA NOCIÓN DE TIEMPO EN UN OBJETO QUE SE DESPLAZA GENERA UN VACÍO- (UN ESPACIO) ESPECÍFICO DENTRO DE LA UNIDAD DEL OBJETO. CON EL MOVIMIENTO DE UNA COSA ALGO SE PIERDE. UBICACIÓN ANTERIOR Y UBICACIÓN POSTERIOR. EL ESPACIO ENTRE LAS DOS UBICACIONES. EL ESPACIO ENTRE DOS PUNTOS. LA DISTANCIA MÁS CORTA ENTRE DOS PUNTOS ES LA LÍNEA RECTA O POR DONDE SOPLE MEJOR EL VIENTO.

ESE ESPACIO ENTRE DOS UBICACIONES (COMO EL FILO DE UNA NAVAJA CORTANDO UNA NARANJA) ES UNA ESTELA DE CONSECUENCIAS HACIA TODAS DIRECCIONES. ESPACIO EXPLOSIVO CONSTANTE HACIA DONDE SEA. PROYECCIÓN DE CÍRCULOS A PARTIR DE UNA LÍNEA RECTA.

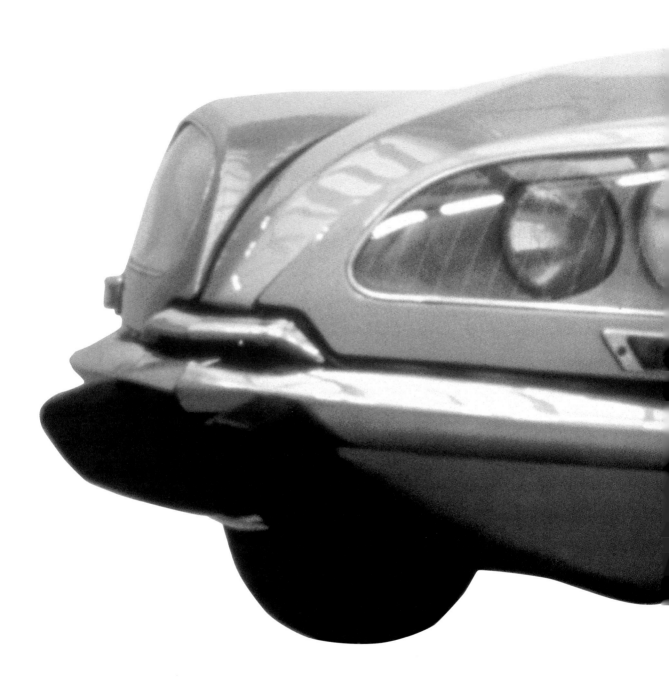

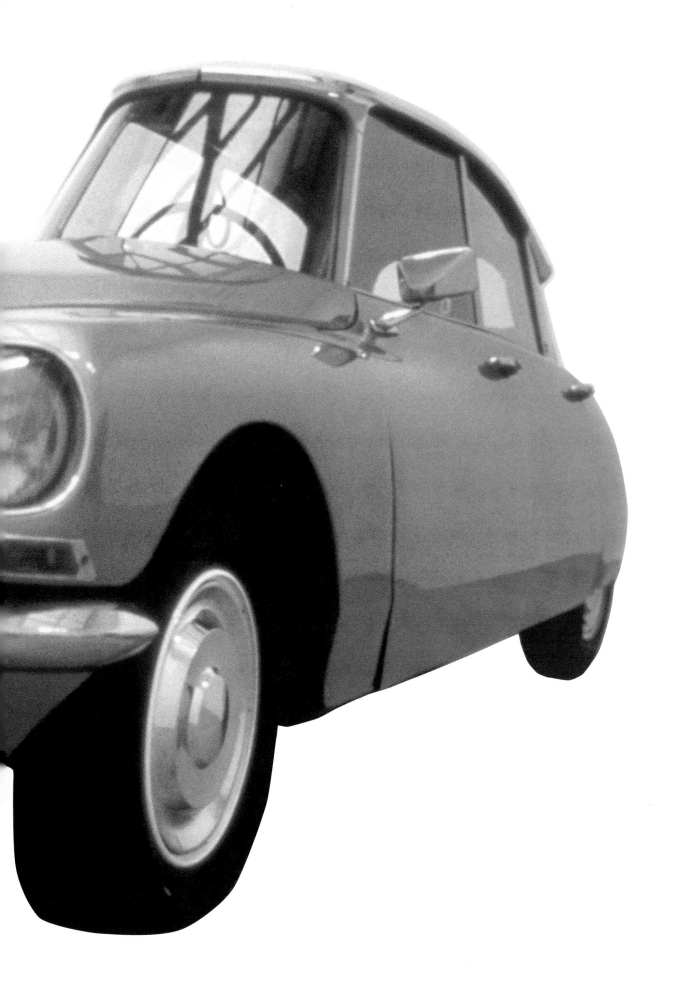

DS:

ILLUSION THREE DIMENSIONAL PERSPECTIVE. PERSPECTIVE AND TIME.
ILLUSION THING AND ITS REFLECTION. INTACT PROFILE WITH A LACK OF DEPTH.
FOREGROUND PROFILE. BACKGROUND BROUGHT NEARER.
FOREHEAD. CENTRAL POINT. DIAGONALS AND VANISHING POINTS HOOD, HEADLIGHTS, BUMPERS,
INSECT. SHIP.

INTERIOR. JOURNEY. ROOM. DISPLACEMENT. HALF OF THE HALF
OF THE HALF OF THE HALF OF THE HALF. TOWARD ITSELF.

THE INTERIOR OF A SCULPTURE. NOT IN PHYSICAL TERMS. BUT IN
A POSSIBLE SYSTEM OF INTERNAL TENSIONS THAT (AS STRUCTURE)
SUPPORTS THE BARK (OR SKIN) OF A THING OR EVENT.

THE "EMPTY" SPACE BETWEEN ONE ACTION AND ANOTHER. BETWEEN TWO HALVES.
IN THE CENTER OF A UNIT IN MOTION. TO INTRODUCE A
NOTION OF TIME IN AN OBJECT THAT MOVES GENERATES A
VOID — (A SPACE) SPECIFIC WITHIN THE UNITY OF THE OBJECT.
WITH THE MOVEMENT OF A THING SOMETHING IS LOST. POSITION
BEFORE AND POSITION AFTER. THE SPACE BETWEEN THE TWO

THE INTERIOR OF A SCULPTURE. NOT IN PHYSICAL TERMS. BUT IN
A POSSIBLE SYSTEM OF INTERNAL TENSIONS THAT (AS STRUCTURE)
SUPPORTS THE BARK (OR SKIN) OF A THING OR EVENT.

THE "EMPTY" SPACE BETWEEN ONE ACTION AND ANOTHER. BETWEEN TWO HALVES.
IN THE CENTER OF A UNIT IN MOTION. TO INTRODUCE A
NOTION OF TIME IN AN OBJECT THAT MOVES GENERATES A
VOID — (A SPACE) SPECIFIC WITHIN THE UNITY OF THE OBJECT.
WITH THE MOVEMENT OF A THING SOMETHING IS LOST. POSITION
BEFORE AND POSITION AFTER. THE SPACE BETWEEN THE TWO
POSITIONS. THE SPACE BETWEEN TWO POINTS. THE SHORTEST DISTANCE
BETWEEN TWO POINTS IS THE STRAIGHT LINE OR WHEREVER
THE WIND BLOWS BETTER.
THAT SPACE BETWEEN TWO POSITIONS (LIKE THE EDGE OF A KNIFE
CUTTING AN ORANGE) IS A WAKE OF CONSEQUENCES IN
ALL DIRECTIONS. CONSTANT EXPLOSIVE SPACE TO
WHEREVER. PROJECTION OF CIRCLES STARTING FROM A STRAIGHT LINE.

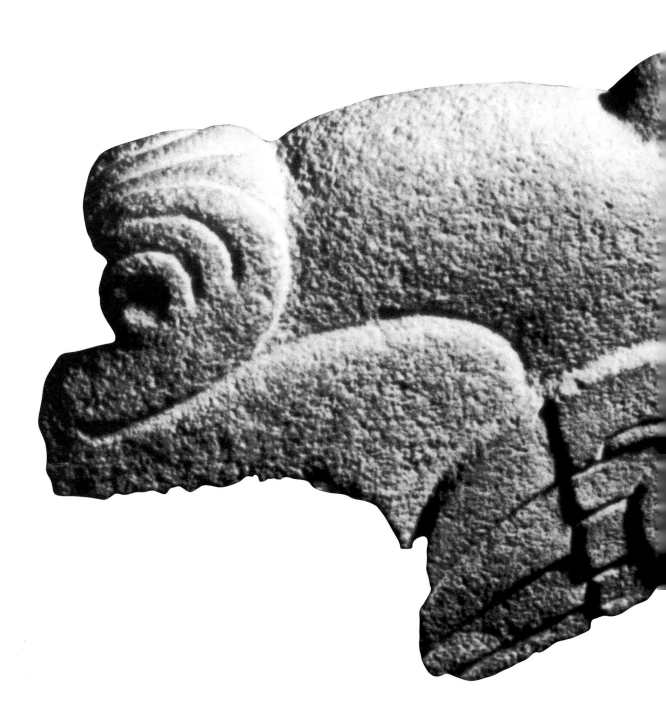

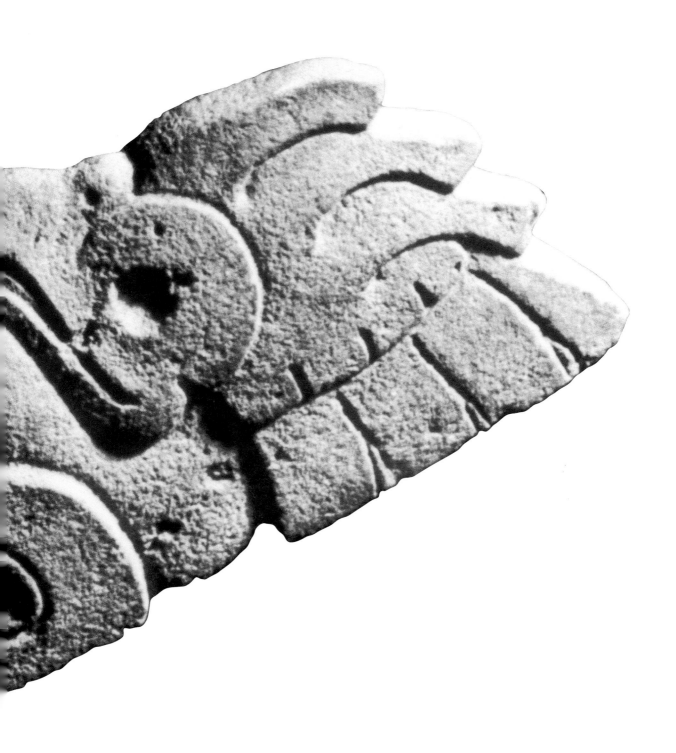

DS. TABLERO DECONSTRUIDO. CRISTAL CON TAJADA. DEFENSA GRIPIO CORTE LIMPID.

DEFENSA: LUZ Y REFLEJO CON CORTE OSCURO. CRISTAL TRANSPARENTE CON CORTE ABIERTO (MÁS TRANSPARENTE Y MÁS OSCURO). CRISTAL TRANSPARENTE CON TENSIÓN INTERNA ENTRE LAS PARTES DE UNA ESTRUCTURA. ESPACIO ENTRE LOS HUESOS.

CORTAR: LA CASA ES ELLA MISMA Y SU REFLEJO. LOS ESPEJOS SON CRISTALES QUE CORTAN.

SOLDAR: LA CASA ES ELLA MISMA Y SU CICATRIZ OSCURA. LOS HONGOS SON ESPEJOS OSCUROS.

ESPEJOS HABITABLES. ESPEJOS ESPERANDO. ESPEJOS PENETRABLES. AGUJERO. ZANJA. CANAL. TUBO. ANILLO. PASILLO. PUNTO DE FUGA.

ATRÁS DEL PUNTO DE FUGA ESTÁ UN ESPACIO HACIA TODAS DIRECCIONES. ATRÁS DEL PUNTO DE FUGA HAY UNA EXPLOSIÓN.

CRUZANDO EL PUNTO DE FUGA ENTRAMOS A UNA NOCIÓN DE ~~TIEMPO~~ PERSPECTIVA TEMPORAL HACIA TODAS PARTES.

PUNTO DE FUGA COMO IMPLOSIÓN. ATRÁS (DESPUÉS) EXPLOSIÓN. DISPERSIÓN.

ACEPTACIÓN DEL CAOS Y VIBRACIÓN DE LA CULPA. MI NACIMIENTO ES UN ACCIDENTE. YO SOY CAOS. SOY UN ERROR. LO ACEPTO Y NO SOY CULPABLE. NO LOS CIENTOS

reflejo. El reflejo de la superficie,
abrir el closet para sacar lo oscuro. proye
transparencias.

volante, dirección, cristal cortado. Horizonte v
distorsionar - la perspectiva (la ilusión de perspe
un hecho real.
La DS es una fotografía tridimensional

.

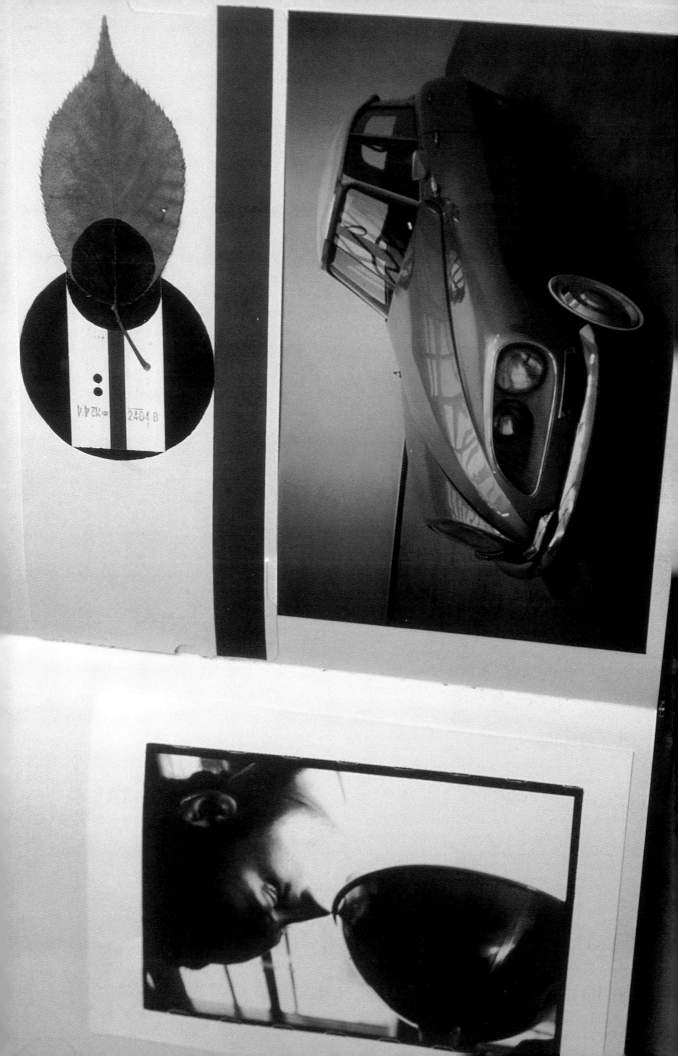

DS. DECONSTRUCTED BOARD. CRYSTAL WITH A CUT. CHROMIUM BUMPER CLEAN CUT.
BUMPER: LIGHT AND REFLECTION WITH DARK CUT. TRANSPARENT CRYSTAL WITH
OPEN CUT (MORE TRANSPARENT AND DARKER).
INTERNAL TENSION BETWEEN THE PARTS OF A STRUCTURE. SPACE
BETWEEN THE BONES.
CUTTING: THE THING IS ITSELF AND ITS REFLECTION. THE MIRRORS ARE CRYSTALS
THAT CUT.
WELDING: THE THING IS ITSELF AND ITS DARK SCAR. THE HOLES
ARE DARK MIRRORS.
HABITABLE MIRRORS. WAITING MIRRORS. PENETRABLE MIRRORS.
HOLE. TRENCH. CANAL. TUBE. RING. CORRIDOR. VANISHING POINT.
BEHIND THE VANISHING POINT THERE IS A SPACE IN ALL DIRECTIONS.
BEHIND THE VANISHING POINT THERE IS AN EXPLOSION.
CROSSING THE VANISHING POINT WE ENTER A NOTION OF ~~TIME~~
TEMPORAL PERSPECTIVE IN ALL DIRECTIONS.
VANISHING POINT AS IMPLOSION. BEHIND (AFTER) EXPLOSION.
DISPERSION.
ACCEPTANCE OF CHAOS AND LIBERATION FROM GUILT.
MY BIRTH IS AN ACCIDENT. I AM CHAOS. I AM A MISTAKE.
I ACCEPT IT AND I AM NOT GUILTY. I DO NOT FEEL GUILTY.

REFLECTION. THE REFLECTION OF THE SHADOW.
TO OPEN THE CLOSET TO TAKE OUT THE DARK. TO SHOW
SLIDES.
STEERING WHEEL, DIRECTION, CUT GLASS. HORIZON
TO DISTORT PERSPECTIVE (THE ILLUSION OF PERSPECTIVE)
A REAL FACT.
THE DS IS A THREE DIMENSIONAL PHOTOGRAPH

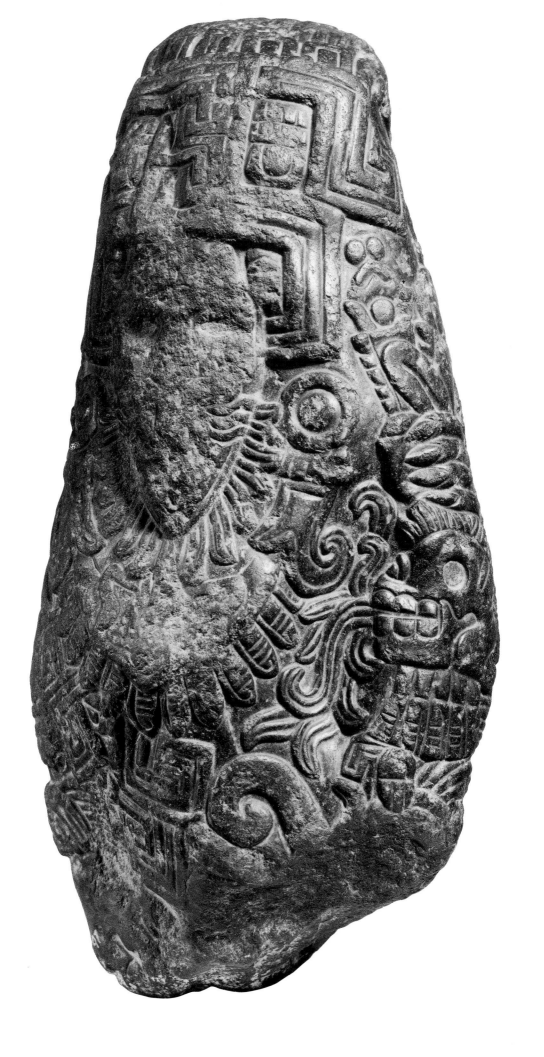

sueña el círculos de pollo. menos silueta que en círculos. Batater en acción conseguia genera una una acción vespa la

consecuencia

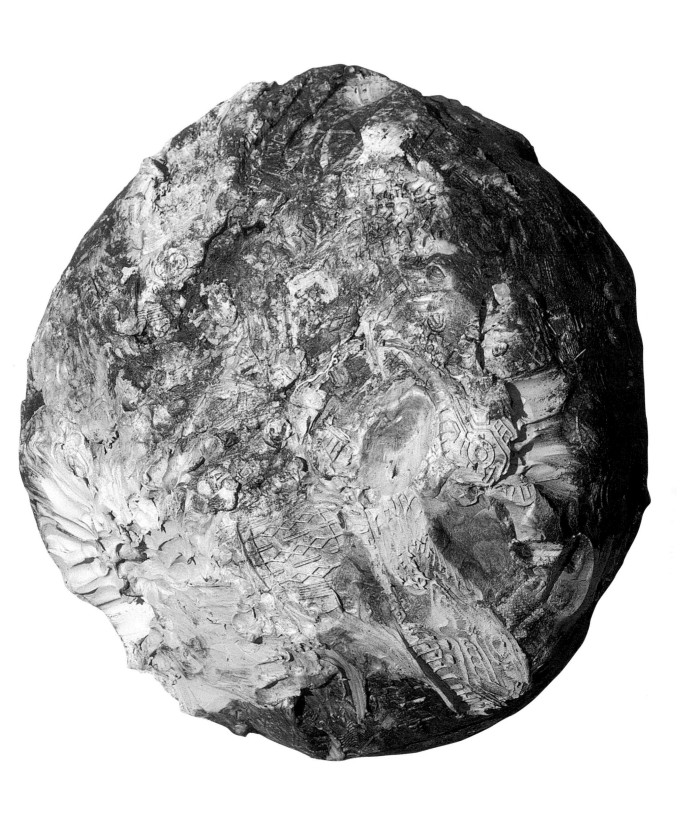

Será construida y rodada entre los días 8 y 14 de octubre en la ciudad de Monterrey.

Elementos de la obra:

La plastilina ~~es una~~ material de uso frecuente para ciertos procesos de la escultura, ~~pero~~ escasamente utilizada ~~como~~ el ~~material~~ definitivo de una obra. Material intermediario entre el ~~gesto del artista~~ y su perdurabilidad ~~como obra de arte, la~~ plastilina suele desaparecer para convertirse en bronce o en ~~tierra.~~ Sabemos que su ductilidad y vulnerabilidad la hacen inapta para formas permanentes en el acabado de una pieza. ~~la plastilina~~ ~~es perdurable pero no su forma ni su apariencia.~~ Por eso me interesa: material de permutabilidad constante, cada vez que se toca cambia, se "accidenta". Entonces, más que modelar su forma, se trata de inducirla, ya que ésta irremediablemente cambiará con el tiempo, como las piedras erosionadas por un río. Por otra parte, como material grasoso y adherente, se "ensucia" fácilmente, cubriéndose de polvo y residuos. Al exponerla al exterior, rodándola por el suelo, utilizo esta cualidad para conformar su apariencia: Camuflaje, no de la piedra a la escultura, sino de la escultura a la piedra; modelar una roca, que no es una roca, sino una bola de plastilina, sucia.

Atentamente,

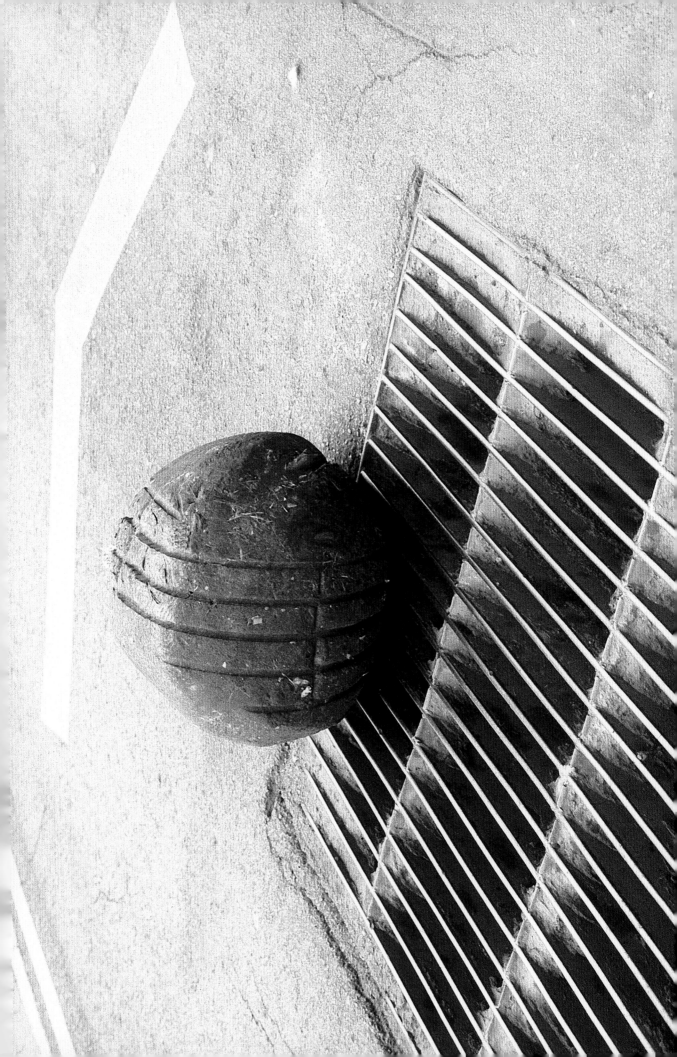

CIRCLES OF DUST.
HANDS SILHOUETTE THAT
TO SWEEP IN CIRCLES.
AN ACTION CONSEQUENCE
THE VESPA GENERATES A
LIKE THE

Will be constructed and rolled around between October 8 and 14 the city of Monterrey.

Elements of the work:

Plasticine, a material often used for some sculptural processes, is hardly ever used for the definitive version of a work. ~~An intermediary material between the artist's gesture and the final form of the work of art, plasticine tends to disappear to convert into bronze or iron.~~ We know that its malleability and vulnerability make it unsuitable for permanent forms in a finished piece. ~~Plasticine is long lasting but not its form or its appearance.~~ That is why it interests me: it is a material in a state of constant mutability, every time that it is touched it changes, it becomes "upset." So, rather than modeling its form, it is a question of inducing it, now irredeemably, it will change with time, like stones worn away by a river. Besides, being a greasy, sticky substance it easily "gets dirty," covered with dust and debris. By exposing it outdoors, rolling it on the ground, I use this quality in order to shape its appearance: camouflage, not of stone into sculpture, but of sculpture into stone; modeling a rock, which is not a rock, nor a sculpture, but a ball of plasticine, dirty.

Yours faithfully,

La plastilina, materia intermediaria entre el gesto del artista y su perdurabilidad en bronce o en hierro, tiene una ductilidad y vulnerabilidad que la hacen inapta para formas permanentes en el acabado de una pieza. La plastilina es perdurable pero no su forma ni su apariencia. Por eso me interesa, cada vez que se toca cambia, se "accidenta". Entonces, más que modelar su forma, se trata de accidentarla y ensuciarla al rodarla por el suelo. De la escultura a la piedra; modelar una roca, que no es una roca, ni una escultura, sino una bola de plastilina, sucia.

Plasticidad: adaptabilidad de un organismo para cambiar en su medio ambiente.

TODO ESTÁ POR HACERSE

EXPOSED TO THE LIGHT OF THE SUN TO IMPRINT THE SILHOUETTE.

ACCUMULATION OF WHITE SHEETS WITH LEAVES (SILHOUETTE) EXPOSED TO THE SUN. WHAT A WASTE.
TO BLOW. TO MODIFY A SPACE WITH A WIND OF BREATH.
TO BLOW.
TO **B L O W** TO BREATHE: TO APPROPRIATE A SPACE AND A TIME.
WITH TRANSFORMATION MIMETIZATION TRANSPORTATION ORGANISM

 Plasticine, the intermediary material between the artist's
gesture and its final form in bronze or iron, possesses a
malleability and vulnerability that make it unsuitable for permanent
forms in the finishing of a piece. Plasticine is
long lasting, but not its form nor its appearance. That is why
it interests me, every time that it is touched, it changes, it becomes "upset." So,
rather than modeling its form, it is a question of upsetting it and dirtying it by
rolling it on the ground. From sculpture to stone; to model a
rock, which is not a rock, nor a sculpture, but a ball of
plasticine, dirty.
 Plasticity: the adaptability of an organism to change in
its environment.

EVERYTHING IS TO

BE DONE

MY WEIGHT IN PLASTICINE

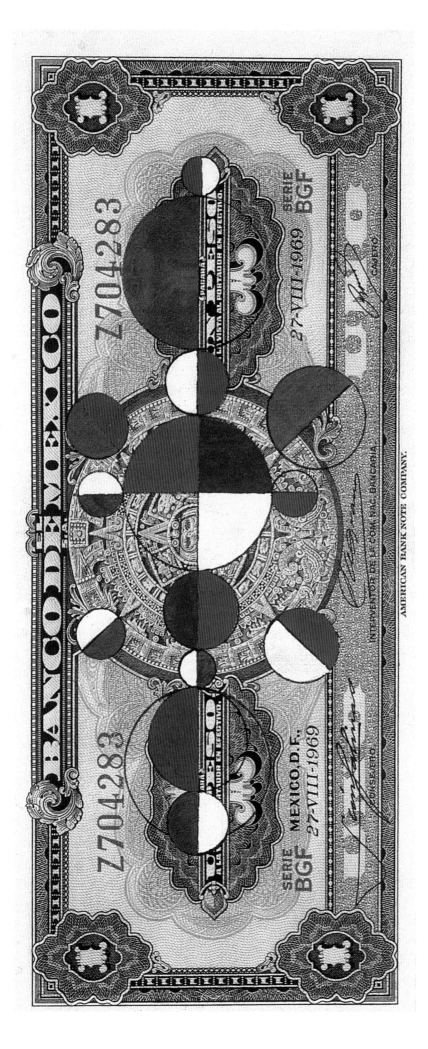

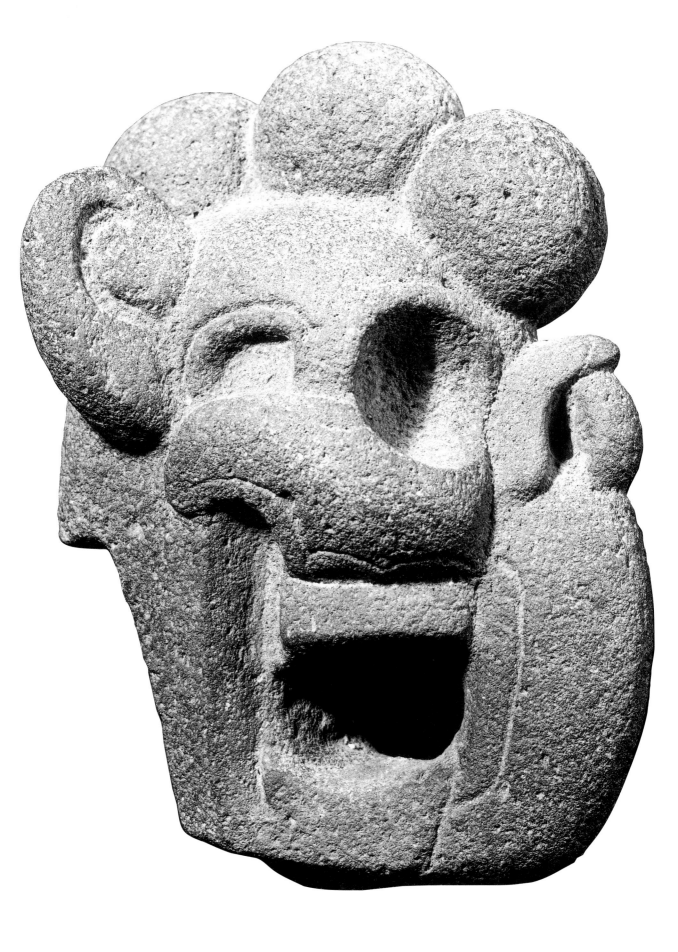

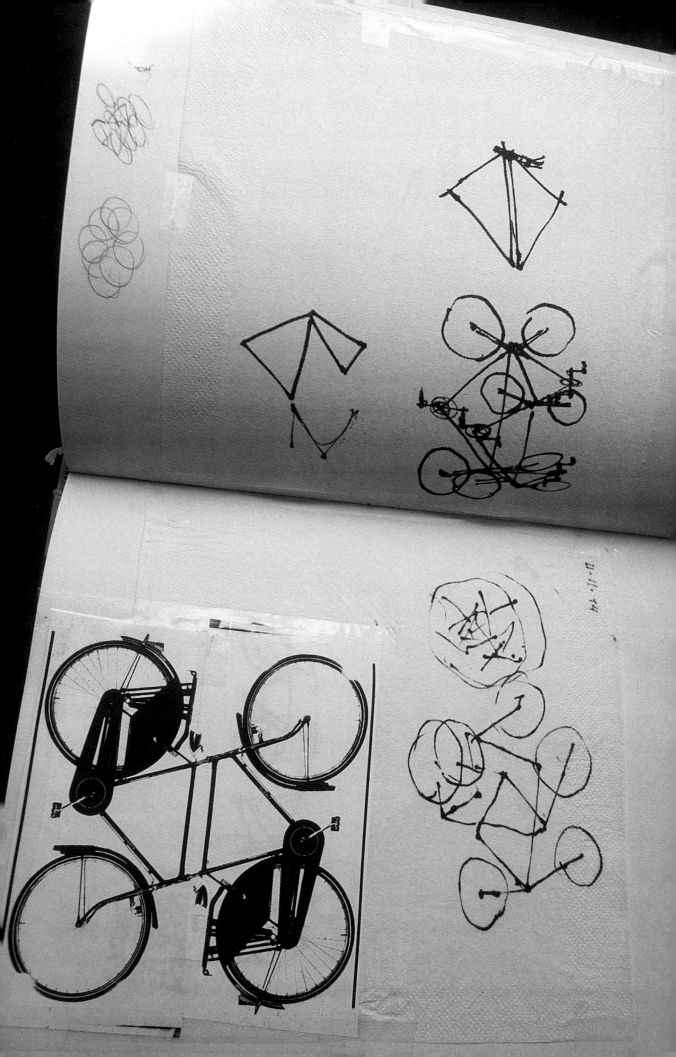

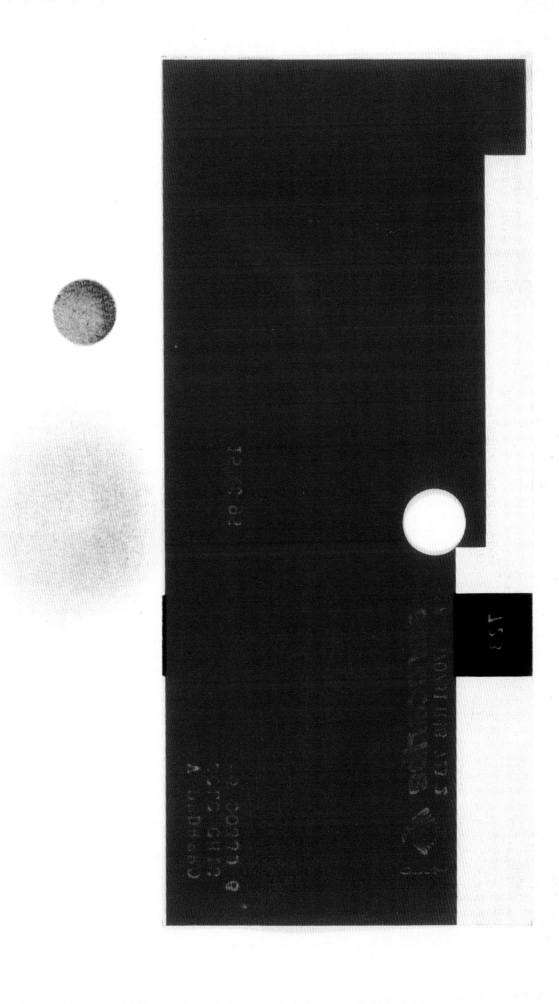

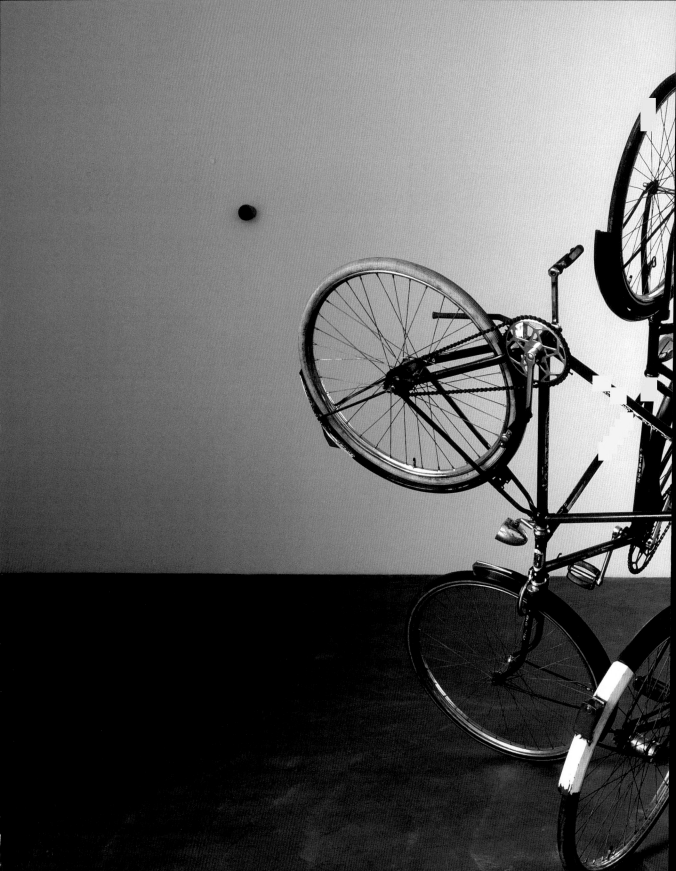

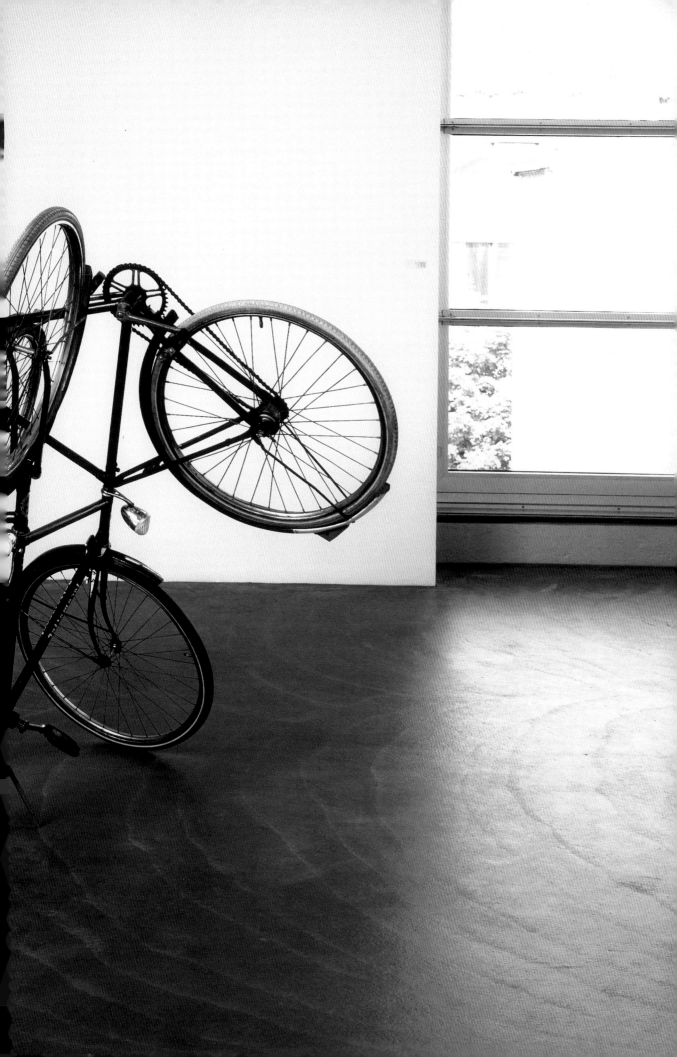

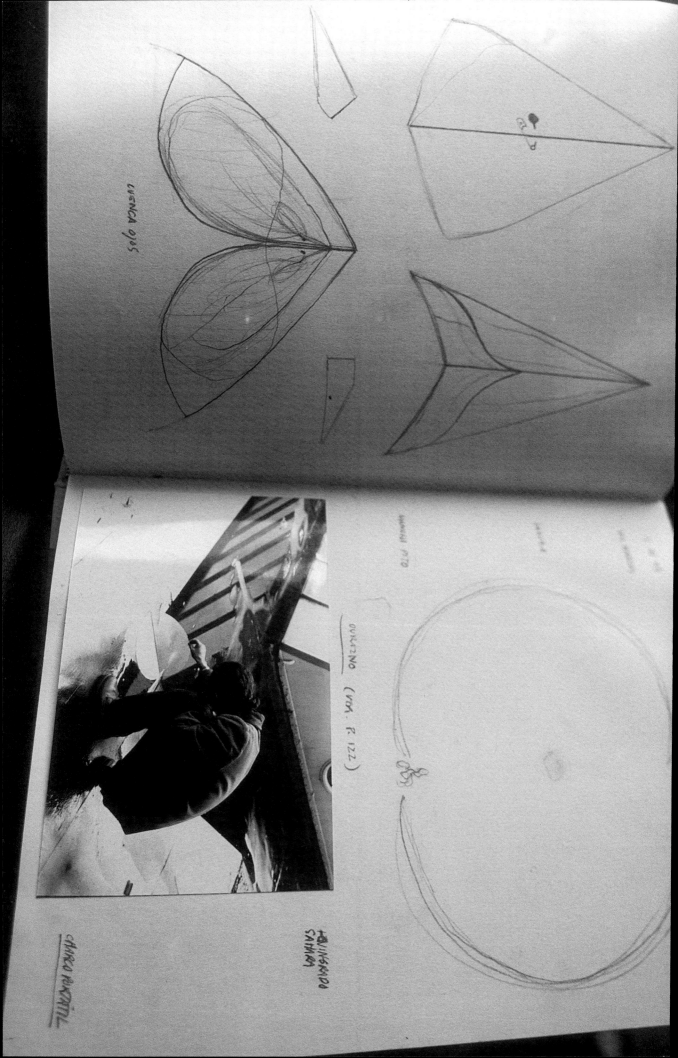

6010:519:675:6

IATA

BOLETO DE PAS~
Y CUPON DE EQUI~

'PAJE

1 FLIGHT - BSP MEXICO
DOMESTIC

ESTE BOLETO NO ES VALIDO Y NO SERA ACEPTADO P/ ~TACION A MENOS QUE HAYA SIDO COMPRADO A LA LINEA AEREA EMISORA O SU
AGENTE DE VIAJES AUTORIZADO POR LA MISMA. POR ~ CONDICIONES DE ESTE CONTRATO.

PEDRA APLAUDIDA.

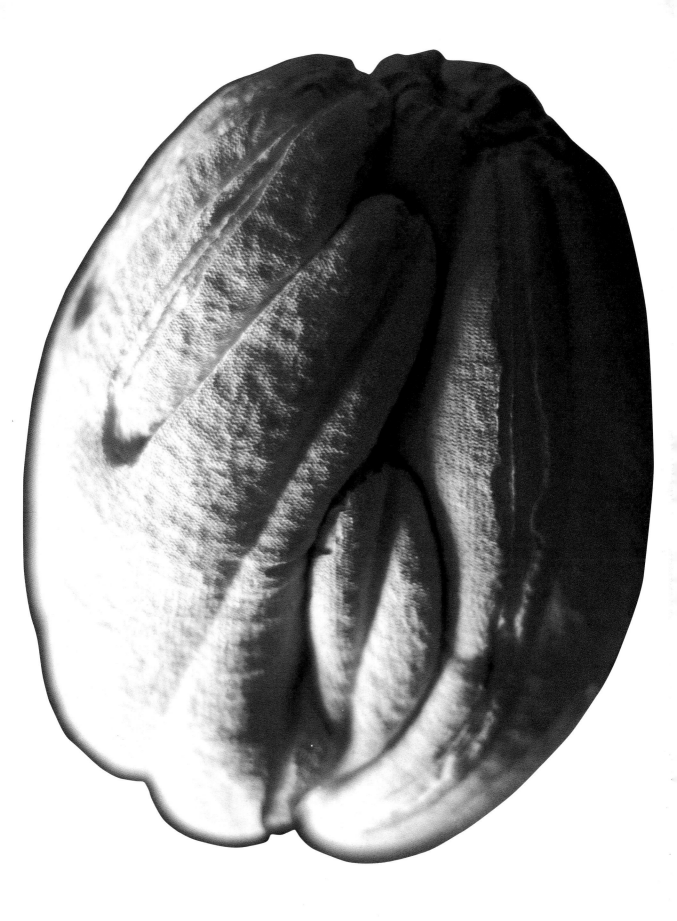

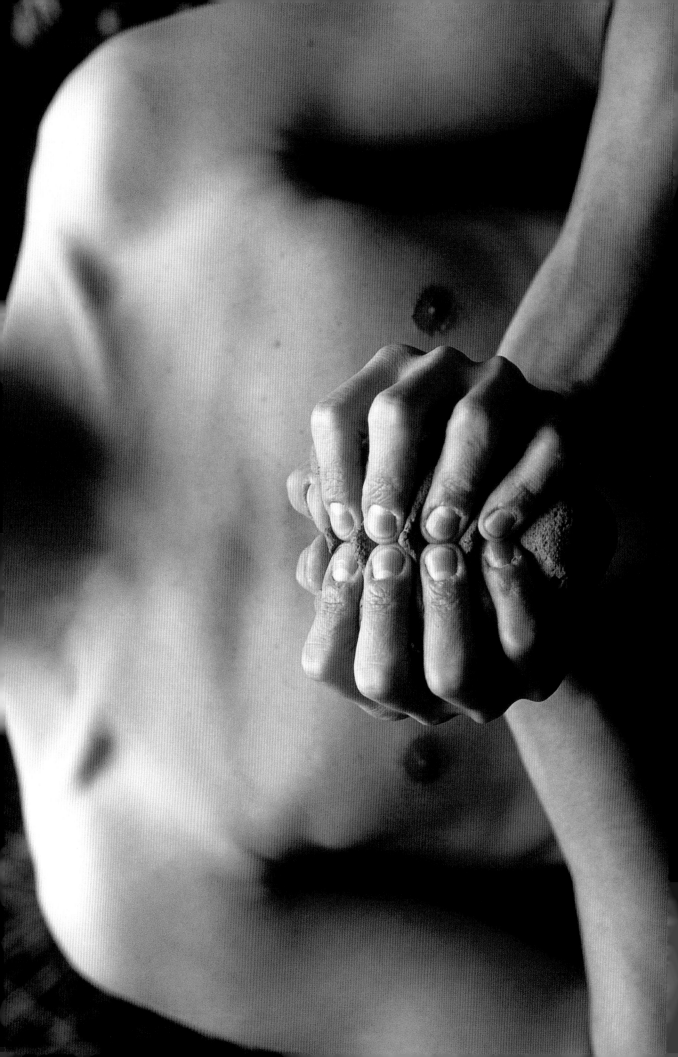

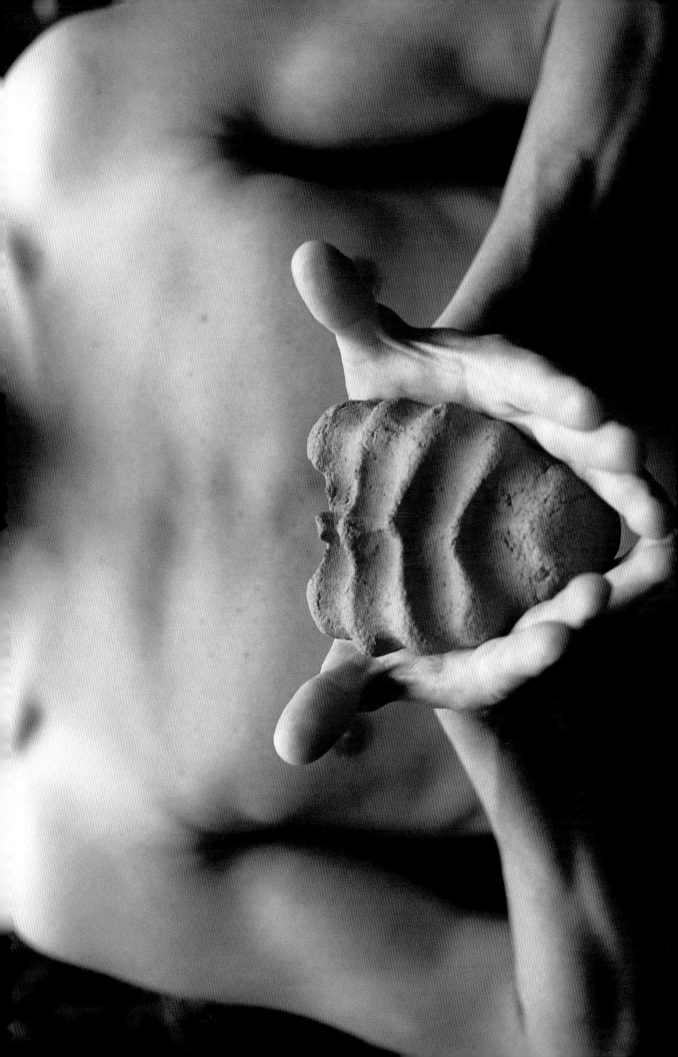

BRILLANTE

VIENTO QUE PASA

DESPEJA LA CLARIDAD DE LAS

Y

PARVADA DE TACTOS. LA DIRE

EN CADA TEXTURA PINTEA OR

DETENERSE CADA MILIMETRO

RESPIRANDO PELOS

APPLAUDED STONE.

WIND THAT PASSES SHINING,
CLEARS THE CLARITY OF THE
AND
FLOCK OF TOUCHES. THE DIRECTION
IN EACH DOTTED TEXTURE
TO STAND STILL AT EACH MILLIMETER
BREATHING FINGERS
THAT TOUCH THE SUBSTANCES

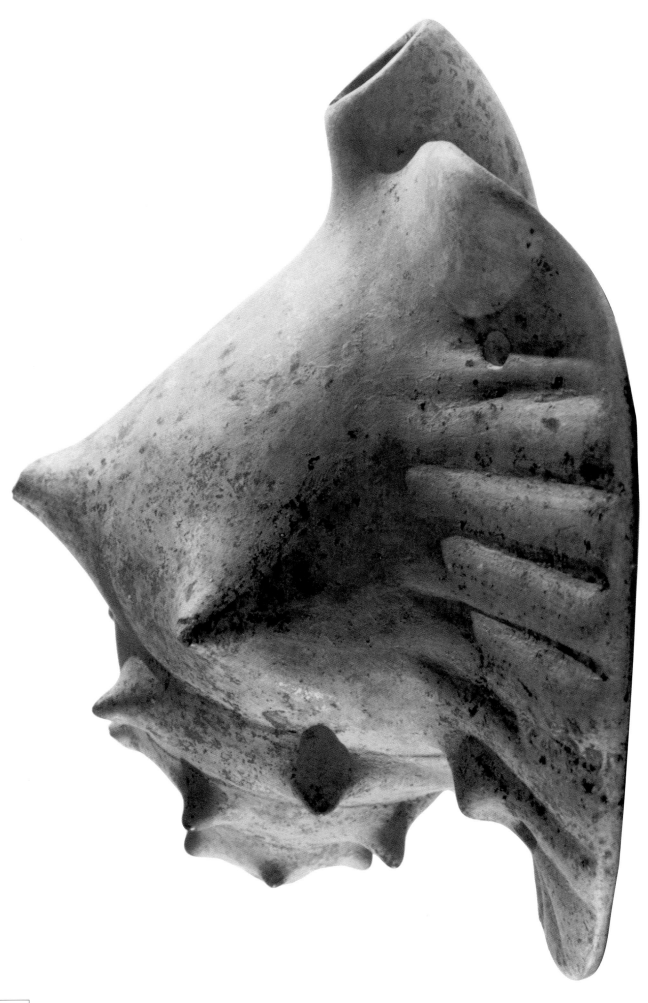

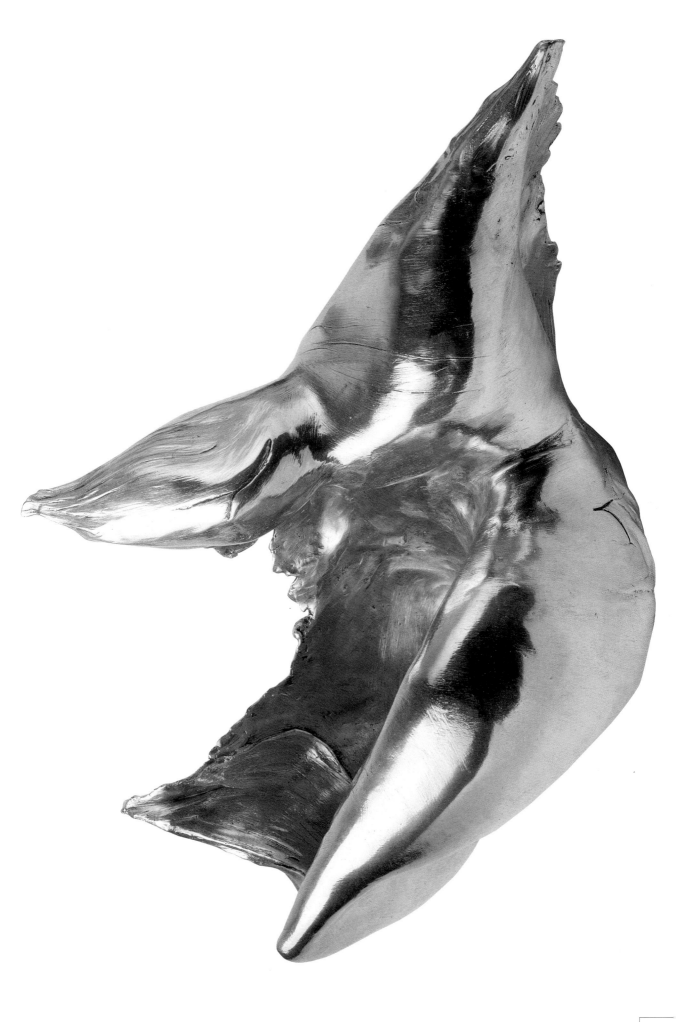

24 - IV - 95

EL SATORI:

EN EL BUDISMO ZEN: (J.L.B.)

"NUESTROS HÁBITOS MENTALES OBEDECEN A LOS CONCEPTOS
DE LO IMPROBABLE. Y A OTROS ESQUEMAS DE ORDEN LÓGI-
QUE PUEDE EXIGIR MUCHOS AÑOS, NOS LIBRA DE ENTI
PARA PROVOCAR EL SATORI, EL MÉTODO MÁS
UNA PREGUNTA CUYA RESPUESTA NO CORRESPONDE
EL EJEMPLO CLÁSICO SE ATRIBUYE A VARIOS
ES EL BUDA? RESPONDIÓ: "TRES LIBRAS DE LINO"
NO ES SIMBÓLICA. A OTRO LE PREGUNTARON: "C
RESPUESTA FUE; "EL CIPRÉS EN EL HUERTO":"
```

NCEPTOS DE SUJETO Y OBJETO, DE CAUSA Y EFECTO, DE LO PROBABLE Y

N LÓGICO QUE NOS PARECEN EVIDENTES; LA MEDITACIÓN,

DE ELLOS Y NOS PREPARA PARA ESE SÚBITO RELÁMPAGO: EL SATORI.

MÁS COMÚN ES EL EMPLEO DEL KOAN, QUE CONSISTE EN

NDE A LAS LEYES LÓGICAS.

VARIOS MAESTROS; A UNO DE ELLOS LE PREGUNTARON: ¿QUÉ

E VINO? LOS COMENTADORES ADVIERTEN QUE LA CONTESTACIÓN

N: ¿POR QUÉ VINO DEL OESTE EL PRIMER PATRIARCA?; LA

TO?.

NO FUE TAN CONSIDERABLE QUE TUVO QUE FUNDAR OTRO

ERA, LOS REUNIÓ A TODOS, LES MOSTRÓ UN CÁNTARO

TARO, DÍGANME QUE ES? EL PRIOR CONTESTÓ: =NO

ERO, QUE IBA A LA COCINA, LE DIO UN PUNTAPIÉ AL

PUSO AL FRENTE DEL MONASTERIO.

ES EL BUDA? RESPONDIÓ: 'TRES LIBRAS DE LINO'.
NO ES SIMBÓLICA. A OTRO LE PREGUNTARON: ¿
RESPUESTA FUE: '¡EL CIPRÉS EN EL HUERTO!'.
NÚMERO DE DISCÍPULOS DE TO-CHANG FU
MONASTERIO. PARA HALLAR QUIÉN LE DIRÍA ERA
Y LES DIJO: 'SIN USAR LA PALABRA CÁNTARO,
ES UN PEDAZO DE MADERA.' EL COCINERO,
CÁNTARO Y PROSIGUIÓ. TO-CHANG LE PUSO

PARA INDUCIR EL SATORI, ALGUNOS MAESTR
EL GRITO, LA BOFETADA Y OTRAS FORMAS DE

... DE ELLOS NOS HACEN EVIDENTES; LA MEDITACIÓN,
DE ELLOS Y NOS PREPARA PARA ESE SÚBITO RELÁMPAGO: EL SATORI.
MÁS COMÚN ES EL EMPLEO DEL KOAN, QUE CONSISTE EN
PONDE A LAS LEYES LÓGICAS.
VARIOS MAESTROS; A UNO DE ELLOS LE PREGUNTARON: ¿QUÉ
DE LINO? LOS COMENTADORES ADVIERTEN QUE LA CONTESTACIÓN
ON: ¿POR QUÉ VINO DEL OESTE EL PRIMER PATRIARCA?; LA
RTO.

NG FUE TAN CONSIDERABLE QUE TUVO QUE FUNDAR OTRO
GERA, LOS REUNIÓ A TODOS, LES MOSTRÓ UN CÁNTARO
ÁNTARO, DÍGANME QUÉ ES." EL PRIOR CONTESTÓ: "NO
TERO, QUE IBA A LA COCINA, LE DIO UN PUNTAPIÉ AL
PUSO AL FRENTE DEL MONASTERIO.

AESTROS SUSTITUYEN EL KOAN POR MEDIOS MÁS VIOLENTOS.
S DE VIOLENCIA FÍSICA.

24-IV-95

<u>SATORI:</u>

IN ZEN BUDDHISM: (J.L.B.)

"OUR HABITS OF MIND OBEY CONCEPTS

OF THE IMPROBABLE. AND OTHER PATTERNS OF LOGICAL ORDER

THAT CAN TAKE MANY YEARS, FREES US FROM

TO PROVOKE SATORI, THE METHOD MOST

A QUESTION WHOSE ANSWER DOES NOT CORRESPOND

THE CLASSIC EXAMPLE HAS BEEN ATTRIBUTED TO SEVERAL

IS IT THE BUDDHA?" HE REPLIED: "THREE POUNDS OF LINEN."

IT IS NOT SYMBOLIC. ANOTHER MASTER WAS ASKED:

ANSWER WAS: "THE CYPRESS IN THE ORCHARD."

THE NUMBER OF PO-CHANG'S DISCIPLES

CONCEPTS OF SUBJECT AND OBJECT, OF CAUSE AND EFFECT, OF THE PROBABLE AND LOGICAL ORDER THAT SEEM OBVIOUS TO US; MEDITATION, FROM THESE AND PREPARES US FOR THE SUDDEN LIGHTNING FLASH: SATORI. MOST COMMON IS THE USE OF THE KOAN, WHICH CONSISTS OF CORRESPOND TO THE LAWS OF LOGIC.

TO SEVERAL MASTERS; ONE OF THEM WAS ASKED: WHAT OF LINEN." COMMENTATORS NOTE THAT THE ANSWER "WHY DID THE FIRST PATRIARCH COME FROM THE WEST?"; THE ORCHARD."

WAS SO CONSIDERABLE THAT HE HAD TO FOUND ANOTHER HE BROUGHT ALL OF THE DISCIPLES TOGETHER AND SHOWED THEM A PITCHER, PITCHER, TELL ME WHAT THIS IS." THE PRIOR ANSWERED: "IT IS NOT WHO WAS GOING TO THE KITCHEN, KICKED OVER THE MADE HIM THE HEAD OF THE MONASTERY.

MASTERS SUBSTITUTE

IS THE BUDDHA?" HE REPLIED: "THREE POUNDS OF LINEN IT IS NOT SYMBOLIC. ANOTHER MASTER WAS ASKED: ANSWER WAS: "THE CYPRESS IN THE ORCHARD."

THE NUMBER OF PO-CHANG'S DISCIPLES MONASTERY. IN ORDER TO FIND SOMEONE TO DIRECT IT AND SAID TO THEM: "WITHOUT USING THE WORD PITCHER A PIECE OF WOOD." THE COOK, PITCHER AND WENT ON HIS WAY. PO-CHANG MADE HIM

TO INDUCE SATORI, SOME MASTERS SHOUTING, BLOWS AND OTHER FORMS OF

LOGICAL THAT SEEM OBVIOUS TO US; MEDITATION,
FROM THESE AND PREPARES US FOR THE SUDDEN LIGHTNING FLASH: SATORI.
MOST COMMON IS THE USE OF THE KOAN, WHICH CONSISTS OF
CORRESPOND TO THE LAWS OF LOGIC.
SEVERAL MASTERS; ONE OF THEM WAS ASKED: WHAT
OF LINEN." COMMENTATORS NOTE THAT THE ANSWER
"WHY DID THE FIRST PATRIARCH COME FROM THE WEST?"; THE
ORCHARD."
WAS SO CONSIDERABLE THAT HE HAD TO FOUND ANOTHER
HE BROUGHT ALL THE DISCIPLES TOGETHER AND SHOWED THEM A PITCHER
PITCHER, TELL ME WHAT THIS IS." THE PRIOR ANSWERED: "IT IS NOT
WHO WAS GOING TO THE KITCHEN, KICKED OVER THE
MADE HIM THE HEAD OF THE MONASTERY.
MASTERS SUBSTITUTE THE KOAN FOR MORE VIOLENT METHODS.
OF PHYSICAL VIOLENCE.

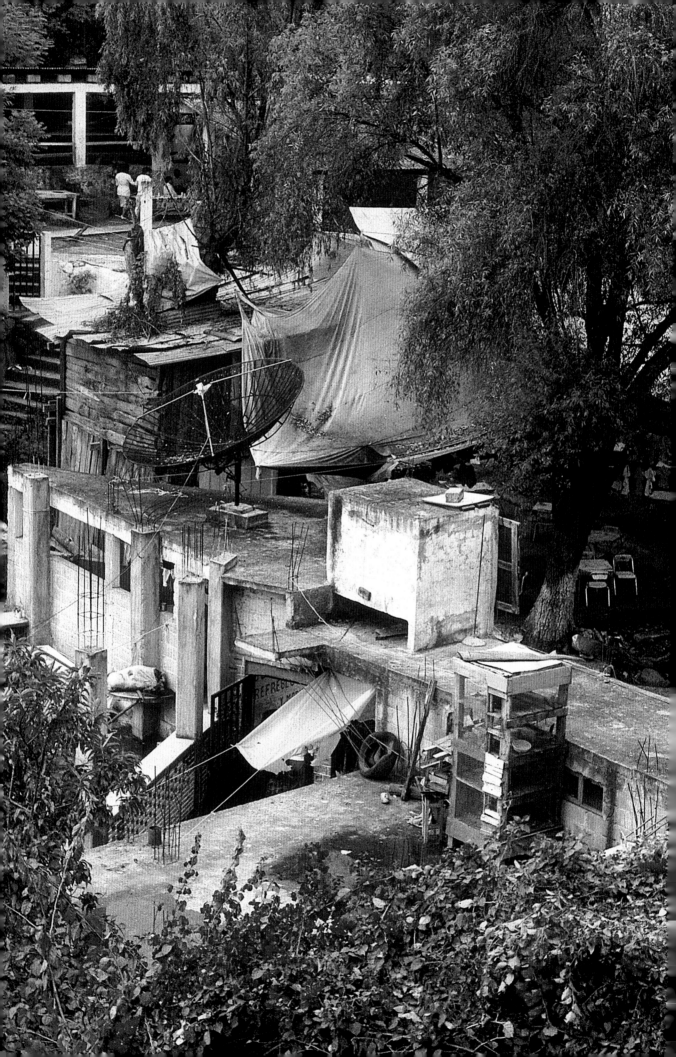

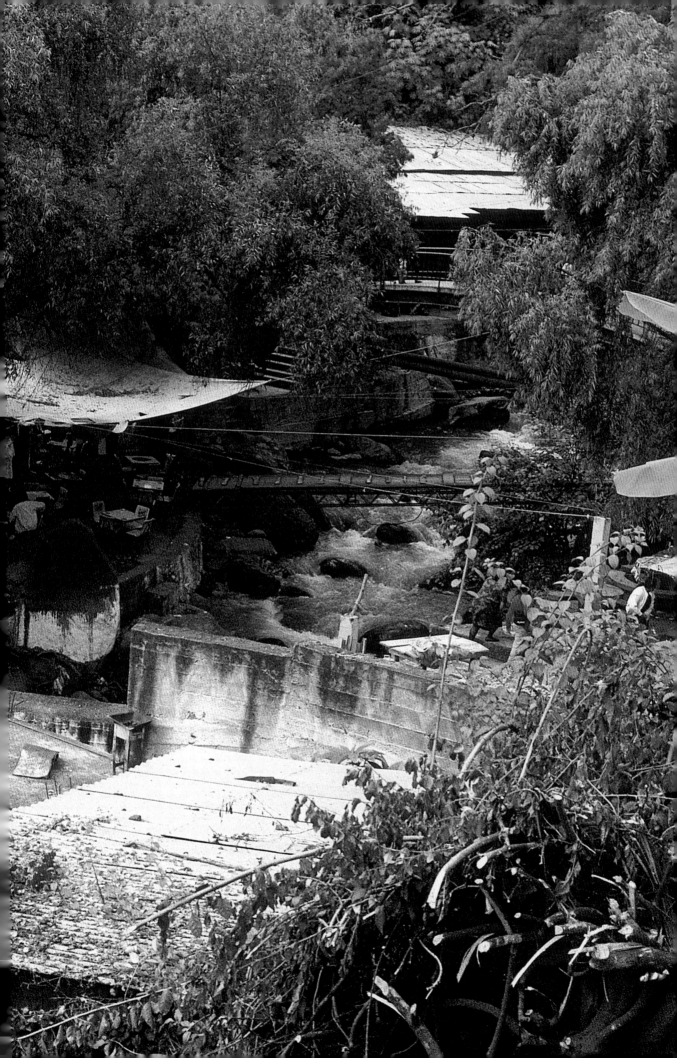

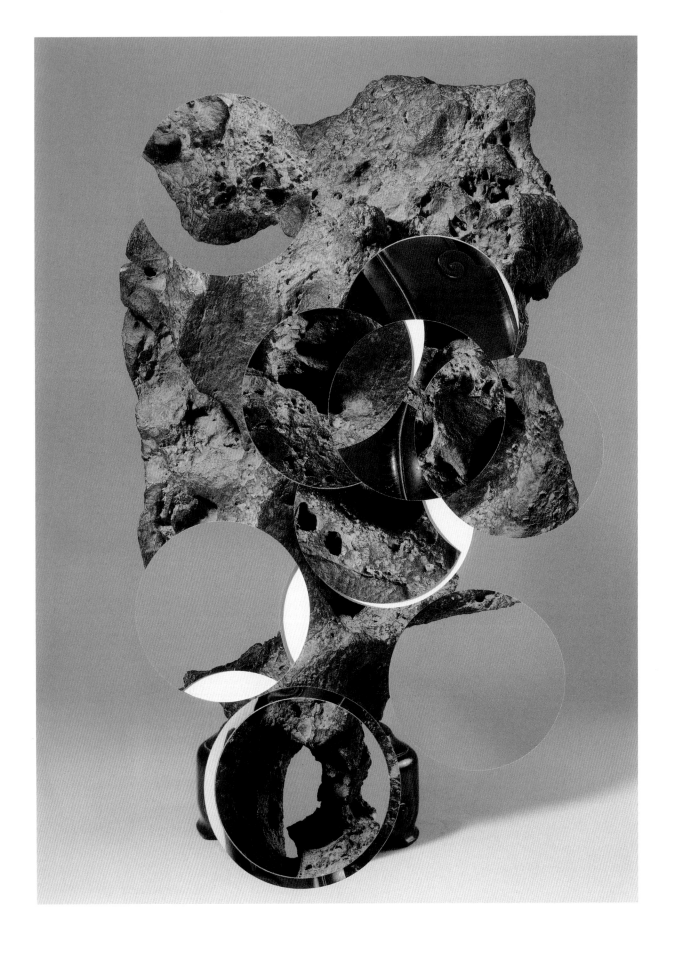

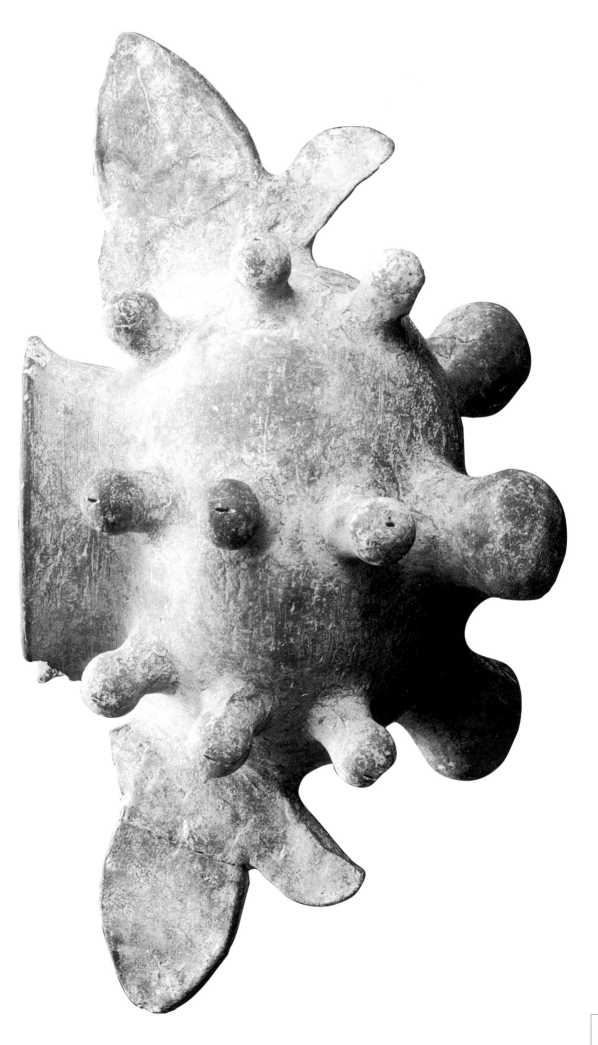

FUERA DE AFUERA Y FUEGO DE AFUERA Y FUEGO DE ADENTRO.

ESAS NO FIJAN; SE DETIENE EN MOVIMIENTO.

LAS COSAS. LAS DETIENE EN FUERZAS ELÁSTICAS EN MOVIMIENTO.

LA TRAICIÓN LOS MOVIMIENTOS PERMANECEN PERMANECER EN EL ESPACIO MA—

FIJAR ES VARIOS DECIDIR DECIMIENDO PERMANECER EN EL ESPACIO

FIJAR ES NO DECIDIR

PLANETAS. ESTRELLAR: SON FORMAS DE RECORRER

SON FORMAS DE LA ESTEPA.

CIRCULAR NUNCA A LOS LÍMITES DE LA CIRCUNFERENCIA EN NINGUNA—

CIRCULAR NUNCA LLEGAR EN TODAS PARTES. LA CIRCUNFERENCIA

SIN CENTRO EN TODAS PARTES.

EL CENTRO EN TODAS PARTES

(P. 26 L. 3)

DEBAJO DEL TERCERO SIEMPRE HAY HUMEDAD

EL TERCERO ES HÚMEDO.

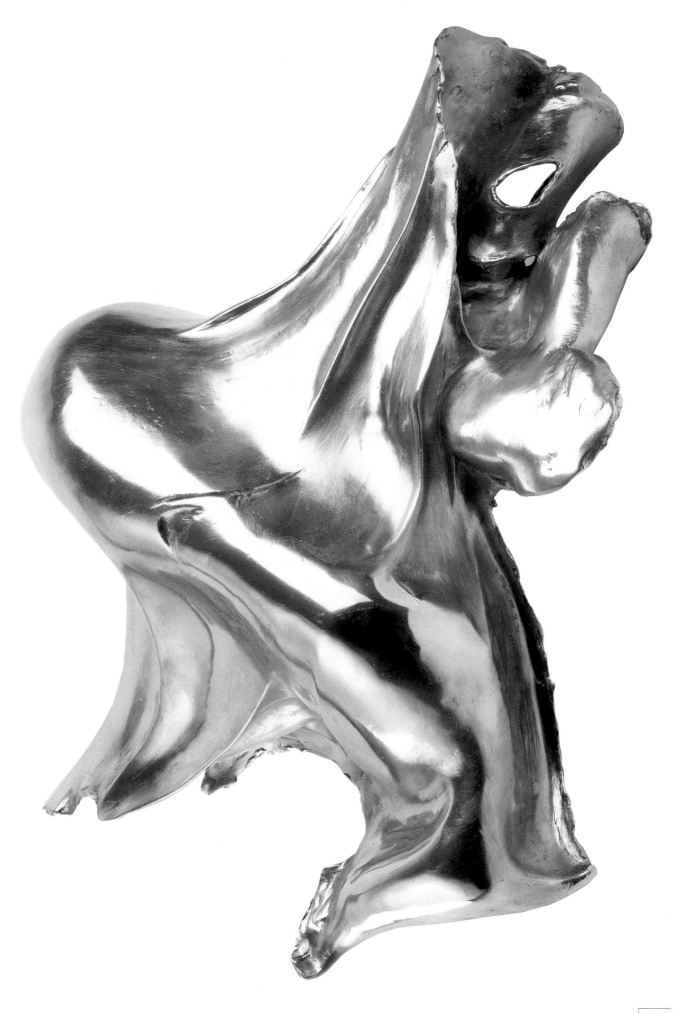

RESTING POINT + RESTING POINT + RESTING POINT.

RESTING POINT + FLOAT. IN MOTION IN DIVERSE INDECISIVE DIRECTIONS.
THINGS DO NOT FLOAT. IN MOTION IN DIVERSE INDECISIVE DIRECTIONS.
FRICTION KEEPS THEM MOVEMENTS IN DIVERSE INDECISIVE DIRECTIONS.
FLOATING IS VARIOUS MOVEMENTS. DECIDING TO STAY IN MOVEMENT.
FLOATING IS NOT DECIDING. THESE ARE WAYS TO DISAPPEAR INTO SPACE
PLANETS. SHATTERING: THESE ARE WAYS TO THE SPHERE.
CIRCLING, EVER REACHING THE LIMITS OF THE SPHERE.
WITHOUT EVER EVERYWHERE. THE CIRCUMFERENCE NOWHERE.
THE CENTER EVERYWHERE. THE CIRCUMFERENCE NOWHERE.

UNDER THE THIRD THERE IS ALWAYS DAMP (P.26 B.3)
THE THIRD IS DAMP.

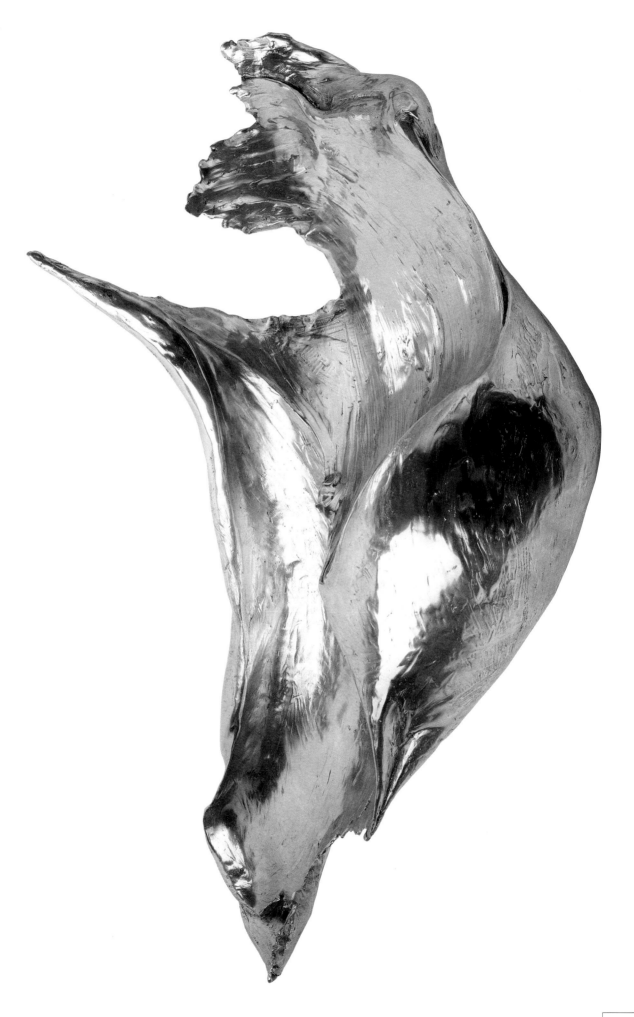

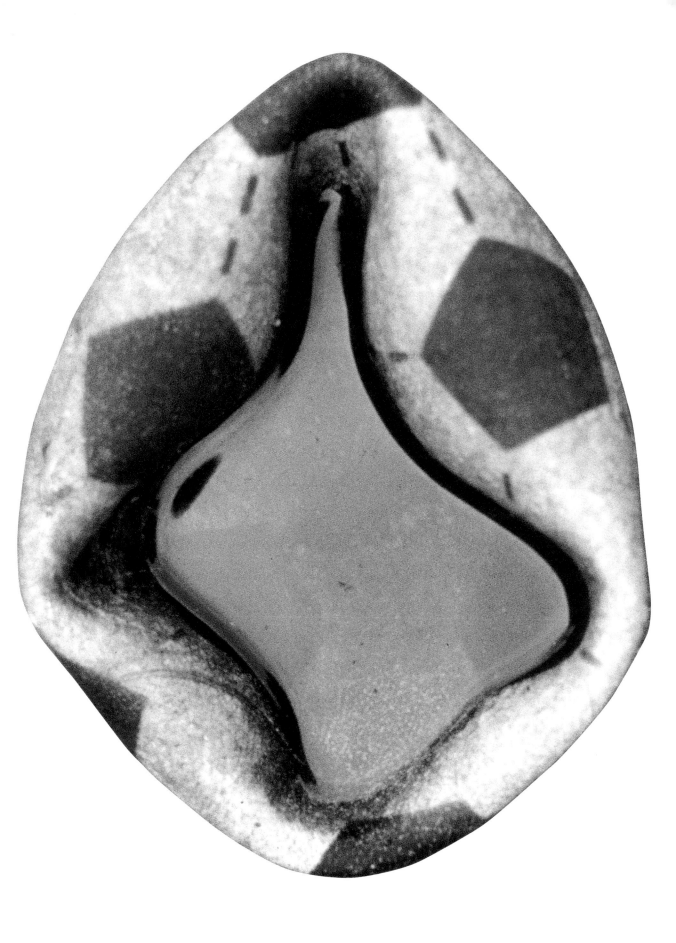

PUDDLE

GOAL

FALL

WAKE.

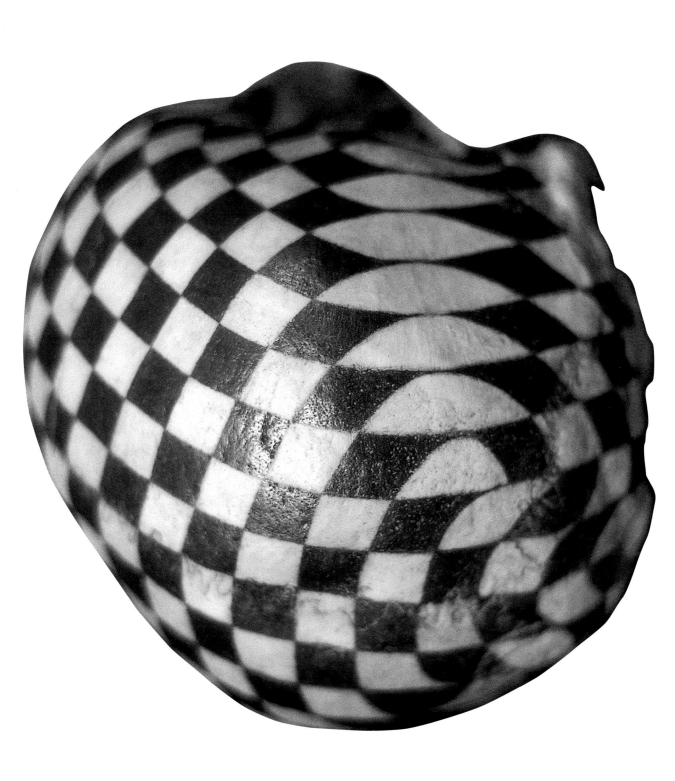

ENAMORARSE DEL DESTINO

DE ATOMOS
FINITOS
DE PRINCIPIO
CONSTANTE
Y ASI
PARA TODA LA ETERNIDAD.

TO FALL IN LOVE WITH THE DESTINY

OF FINITE

ATOMS

OF CONSTANT

BEGINNING

AND THUS

FOR ALL ETERNITY.

DIBUJAR SOBRE ESTRUCTURA OSEA DESCRIBIENDO EL OCIO TRIDIMENSIONAL.

LINEA SOBRE VOLUMEN. TOPOGRAFIA DEL CRANEO. ENTRANDO EN LOS

OJOS. PERDIÉNDOSE. RETRATO DE UN ESPACIO. ESPACIO QUE

SUCEDE. SUCESIÓN DE LÍNEAS, ESPACIOS Y TIEMPO. MATAR

EL TIEMPO.

RED DE PENSAMIENTO. CONEXIONES. CONCIENCIA COMO RETICULA

SE PERCEPCIÓN.

DIBUJO DE LA NADA. EL VOLUMEN DEL NO. RECIPIENTE VACÍO.

COMO CAJA DE ZAPATOS.

MIRADA COMO ESPACIO.                    RECIBIENDO.

MIRADA COMO ESPACIO QUE RECIBE.
                    COMO RECIPIENTE

PASAR EL TIEMPO CON LA NADA. PERDER EL TIEMPO.

RAYAS EN EL AGUA.

LAPICERO COMO BISTURÍ

SKULLPTURE.
—————

CON EL DIBUJO APLANAMOS LA IMAGE    EL OBJETO    VOLUMEN HECHO GRÁFICA.

OBJETO HECHO IMAGEN

COMO LA BASE DE LA OLLA R

LA BASE DE LA OLLA.

PENSAR LA MIRADA - DESCRIBIR LA CARA. T

PURO, EL PAISAJE DEL PENSAMIENTO.

VOLUMEN DE VIÑETAS - DE LUCES.

PAPALOTES NEGROS.

TO DRAW ON A BONE STRUCTURE DESCRIBING THE THREE-DIMENSIONAL IDLENESS.
LINE OVER VOLUME. TOPOGRAPHY OF THE CRANIUM. ENTERING THE
EYES. LOSING ITSELF. PORTRAIT OF A SPACE. A SPACE THAT
HAPPENS. SUCCESSION OF LINES, SPACES AND TIME. TO KILL
TIME.
GRID OF THOUGHTS. CONNECTIONS. AWARENESS AS A GRID
OF PERCEPTION.
A DRAWING OF NOTHINGNESS. THE VOLUME OF NO. EMPTY RECEPTACLE.
LIKE A SHOE BOX.
THE GAZE AS SPACE.
THE GAZE AS SPACE THAT RECEIVES, RECEIVING.
AS RECEPTACLE
TO SPEND TIME WITH NOTHINGNESS. TO WASTE TIME.
LINES ON WATER.
PENCIL AS SCALPEL

SKULLPTURE.

WITH THE DRAWING WE FLATTEN ~~THE IMAGE~~ THE OBJECT. VOLUME MADE GRAPHIC.
OBJECT MADE IMAGE

LIKE THE BASE OF THE POT
THE BASE OF THE POT.

TO THINK THE GAZE. TO DESCRIBE THE FACE.
PURE. THE LANDSCAPE OF THOUGHT.
VOLUME ~~OF LINE OF LINES.~~ ~~OF~~ LIGHTS.
BLACK KITES.

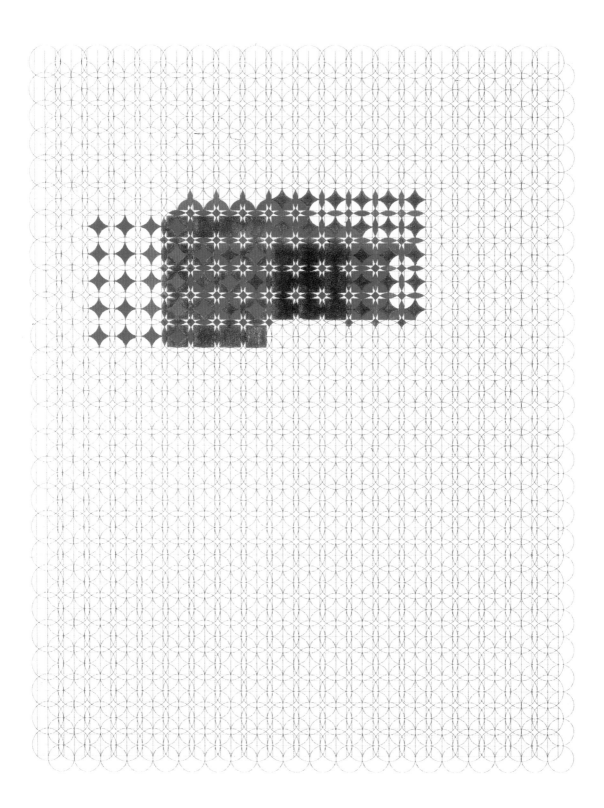

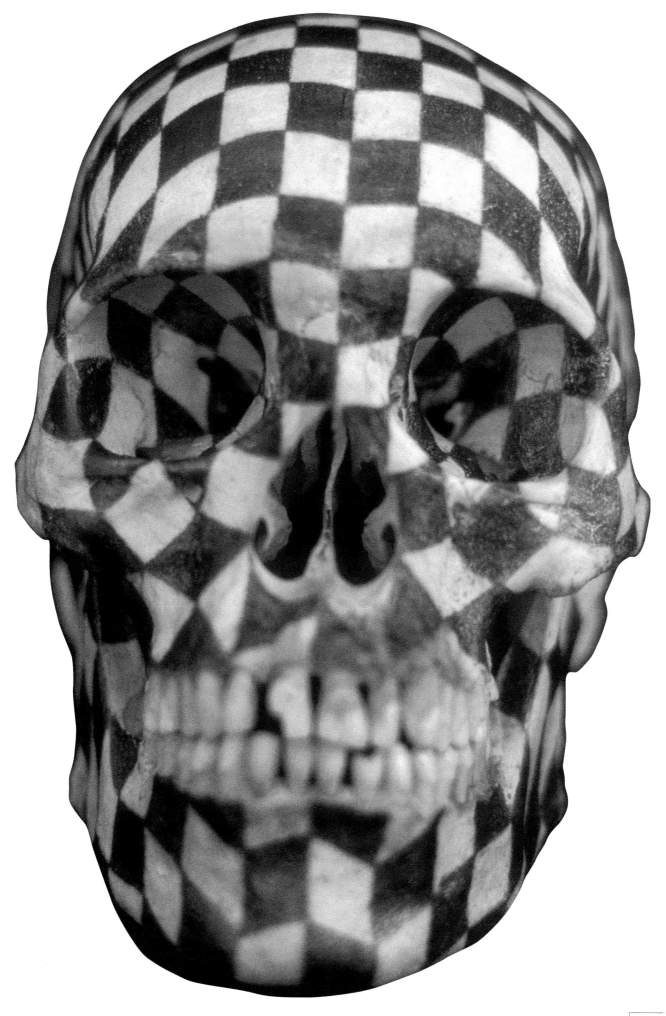

CAMPO ABIERTO — CAMPO CERRADO.

ARRIBA — ABAJO: CORTE HORIZONTAL EN EL MEDIO. LINE HORIZONTE. ESPACIO ABI...
SEÑAL. NOMINAL.
VOLTEAR LA GALERIA HACIA ABAJO.

EL PUNTO DE FUGA ESTÁ EN LA NUCA.
(LA CUARTA TAPA, LA "CIEGA", LA QUE NO VEMOS, LO SEÑALA).
NUESTRA MEMORIA DE LO PASADO INMEDIATO.

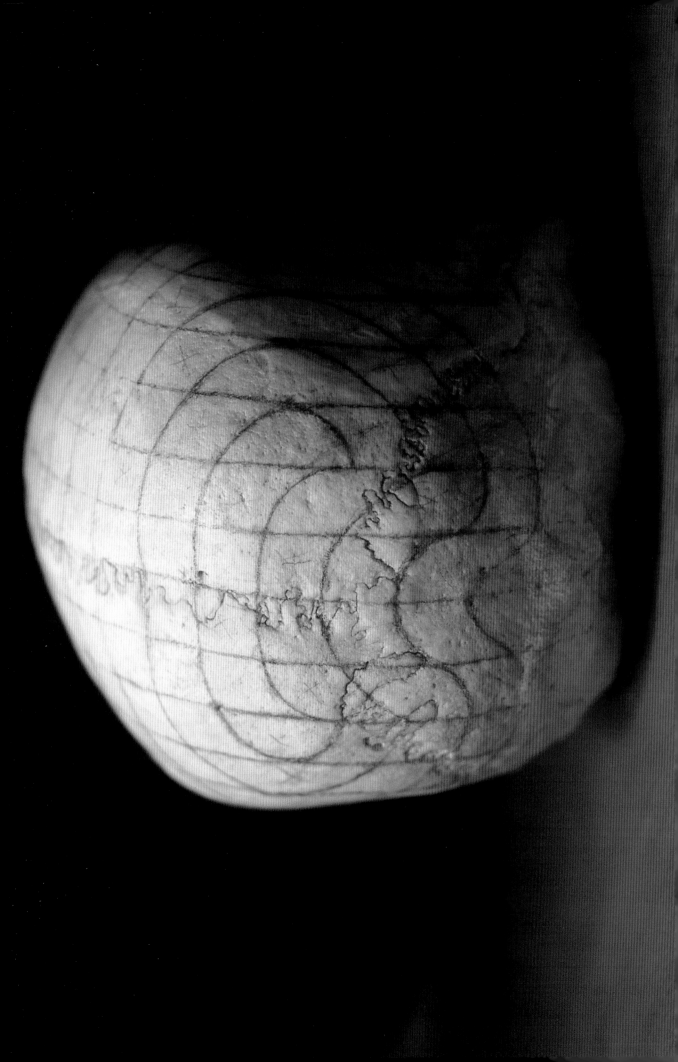

OPEN FIELD - CLOSED FIELD.

ABOVE - BELOW: HORIZONTAL CUT IN THE MIDDLE. HORIZON LINE. OPEN SPACE.
SIGNAL. NOMINAL.
TURN THE GALLERY UPSIDE DOWN.

THE VANISHING POINT IS IN THE NAPE.
(THE FOURTH CAP, THE "BLIND," THE ONE WE CANNOT SEE, IT POINTS IT OUT.)
OUR MEMORY OF THE IMMEDIATE PAST.

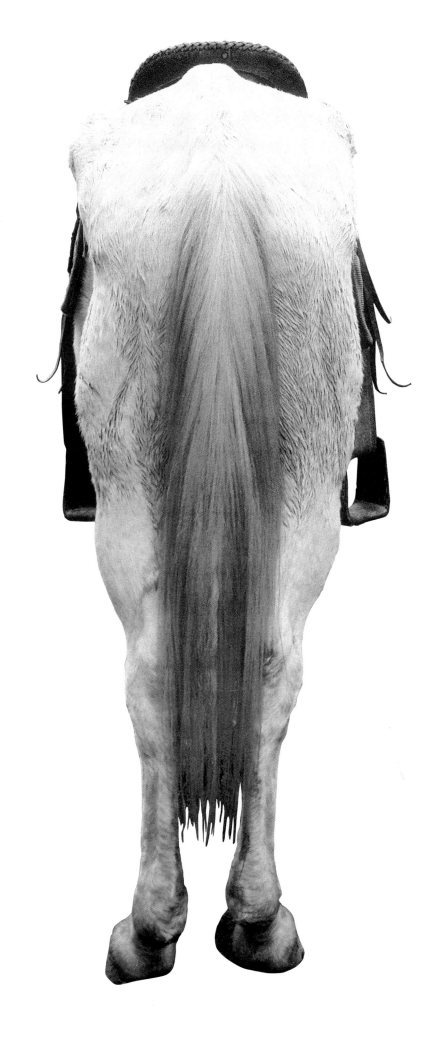

5 V 93

TODA ACCIÓN CONLLEVA UN ESPACIO VACÍO. LA ESTELA DESPUÉS DEL VUELO. EL ESPACIO ENTRE LAS DOS ESTELAS QUE CHOCARON CONTRA EL CUERPO CORRIENDO Y QUE PARTIÓ EL AIRE EN DOS MITADES. ¿QUÉ SUCEDE EN EL ESPACIO POSTERIOR INMEDIATO DE ESE CUERPO? (¿EN EL ESPACIO POSTERIOR ENTRE LAS DOS ESTELAS DE AIRE VIENTO? TRIÁNGULO. PIERNAS ABIERTAS, VIENTO POSTERIOR AL ACTO. VACÍO DE LA ACCIÓN. DEL VACÍO ZAMBULLIRSE EN ESE ESPACIO VACÍO DE LA ACCIÓN, ZAMBULLIRSE EN EL VACÍO DE ABRIR LAS PIERNAS, ZAMBULLIRSE EN EL VACÍO DE UNA MUJER QUE VACÍA ESE ESPACIO PARA SER OCUPADO. VACÍO LLENO ENTRE LAS DOS ESTELAS DE UN CUERPO EN ACCIÓN. EN LA COLUMNA NO NOS ATRÁS. TOCA EL AIRE MIENTRAS CORREMOS A NUESTROS LADOS EL AIRE Y GENERAMOS CORTAMOS EL AIRE Y GENERAMOS UN VACÍO A NUESTRAS ESPALDAS. EL VACÍO DE LO NO OCUPADO. EL VACÍO DE NUESTRA AUSEN- CIA. EL VACÍO ENTRE DOS ESTELAS DE VIENTO. EL CUCHILLO CORTANDO Y CHOCANDO CONTRA LA MESA. VACÍO DOBLE: ENTRE LAS DOS MI- TADES DE LA NARANJA Y ENTRE LOS DOS LADOS DEL FILO DEL CUCHILLO.

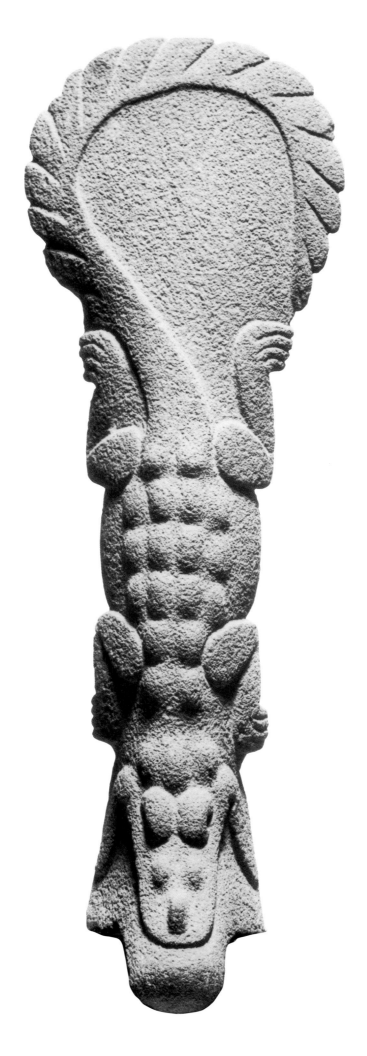

5 V 93

EVERY ACTION IMPLIES AN EMPTY SPACE. THE WAKE AFTER
THE FLIGHT. THE SPACE BETWEEN TWO WAKES THAT COLLIDED
WITH THE RUNNING BODY AND CUT THE AIR INTO
TWO HALVES. WHAT HAPPENS IN THE SPACE IMMEDIATELY
BEHIND THIS BODY? IN THE SPACE BETWEEN THE
TWO WAKES OF AIR WIND? TRIANGLE. LEGS
OPEN, WIND BEHIND THE ACT.
PLUNGING INTO THAT SPACE FULL OF THE VOID
OF THE ACTION. VOID OF THE ACTION OF OPENING
THE LEGS. PLUNGING INTO THE VOID OF
A WOMAN WHO EMPTIES THAT SPACE
SO THAT IT CAN BE OCCUPIED.
FULL VOID BETWEEN THE TWO WAKES
OF A BODY IN ACTION.
BEHIND. IN THE COLUMN THE AIR
DOES NOT TOUCH US AS WE RUN.
THE WIND PASSES AT OUR SIDES.
WE CUT THE AIR AND GENERATE
THE VOID BEHIND US.
THE VOID OF THE UNOCCUPIED.
THE VOID OF OUR ABSENCE.
THE VOID BETWEEN
TWO WAKES OF WIND.
THE KNIFE CUTTING
AND STRIKING AGAINST
THE TABLE. DOUBLE VOID
BETWEEN THE TWO
HALVES OF THE
ORANGE AND
BETWEEN THE
TWO SIDES
OF THE
KNIFE
BLADE.

158

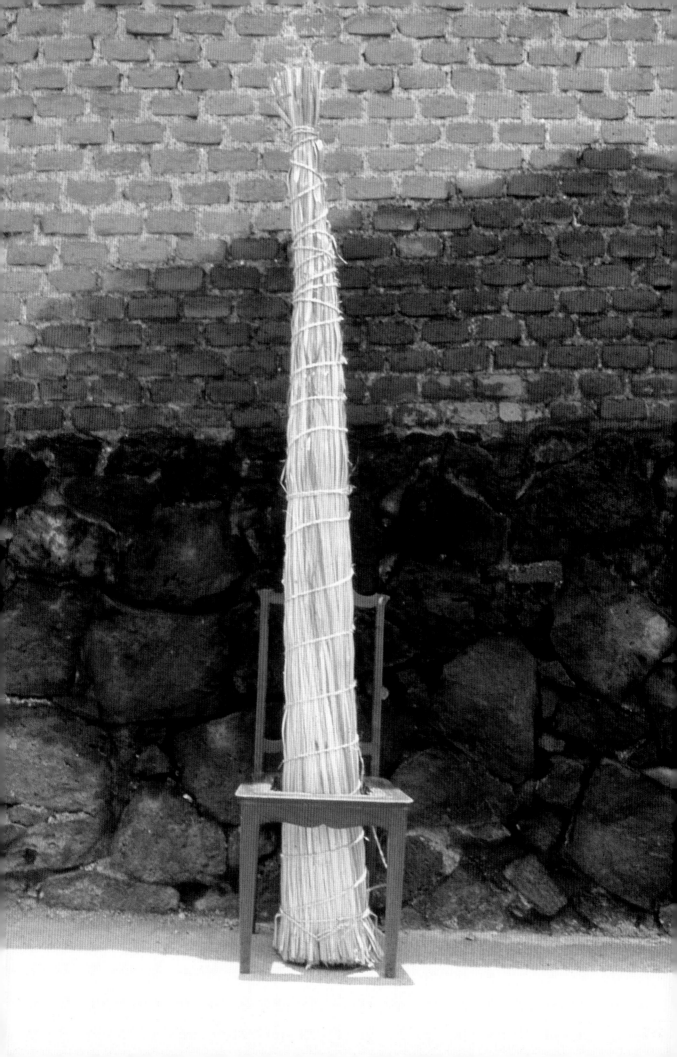

6.VIII.94

YO LO VI, YO LO HICE.

LA JUSTIFICACIÓN DE LOS ACTOS, UN MÉTODO COMPRENSIBLE QUE GENERA UN HECHO COMPRENSIBLE GRACIAS AL MÉTODO, NO AL HECHO EN SÍ. JUSTIFICAMOS NUESTROS ACTOS, CON MÚLTIPLES RAZONES, PARA LOS DEMÁS. ACTO COMUNICADO A TRAVÉS DEL CÓDIGO COLECTIVO. PORQUÉS, PARA QUÉS, AUNQUE EL RESULTADO SEA UNA MIGAJA DE PAN; SI SE COMPRENDE EL MÉTODO, SE COMPRENDE EL HECHO. *

LOS HECHOS (LAS COSAS) PARECEN DESORDENARSE (NO LO ESTÁN) Y NOSOTROS LES DAMOS SENTIDO.

PERO USTEDES NO VEN LO MISMO QUE YO. DONDE USTEDES VEN DESORDEN O BANALIDAD YO VEO NO POCAS RAZONES Y SENTIDOS. ESE LABERINTO DE TRIVIALIDADES, QUE POR EL HECHO DE ESTAR JUNTAS, LLAMAMOS UNIVERSO. ESAS MÚLTIPLES DIRECCIONES CHOCANTES EN EL RÍO DE ESO QUE LLAMAMOS "BASURA".

YO NO VEO GRAN DIFERENCIA ENTRE UN JARRÓN CHINO Y UN VASO ARRASTRADO DE PAPEL ENCERADO EN EL SUELO. NO COMPRENDO NINGUNO DE LOS DOS. PERO LOS TENGO ENFRENTE Y LOS VEO. LOS VEO COMO USTEDES VEN UNA PIRÁMIDE. COMO UN ORDEN DESCONOCIDO. LO AJENO QUE NOS ES REVELADO. LOS DIOSES DE OTROS. (YO TAMPOCO PERTENEZCO A LAS PIRÁMIDES).

(LA INTENCIÓN ES UN HECHO)

...(LA INTENCIÓN ES UN HECHO).

* CUANTOS HECHOS (PROPÓSITOS, DESEOS) GUARDAMOS DENTRO SIN PODER SACARLOS PORQUE NO ENCONTRAMOS EL MÉTODO, QUE EN REALIDAD ES UNA DEMANDA DE LOS OTROS. LAS RAZONES DE NUESTRO DESEO INCOMPRENSIBLES Y NO ACTUAMOS SIN JUSTIFICACIÓN. EL PÚBLICO NECESITA LOS POR QUÉ. NOSOTROS NO.
EL OTRO
LOS DEMÁS

NO HAY UN PORQUÉ COMPRENSIBLE, TOTAL, ILUMINADOR DE UN ACTO AMOROSO.
NO HAY UN POR QUÉ PARA LA POESÍA.
LO POÉTICO NO ES EL PRODUCTO DE UN MÉTODO. NO ES NI SIQUIERA JUSTIFICABLE.
NO ES NI SIQUIERA CREÍBLE.
¿CÓMO CREER EN LO POÉTICO? ¿COMO UN ESPÍRITU RACIONAL PUEDE CREER EN LO INCOMPRENSIBLE?

CREER ES MENTAL. LO POÉTICO NO ES NI SIQUIERA IRRACIONAL. NO ES NI SIQUIERA EMOCIONAL. ES ANTIRELIGIOSO.
ES OTRA CLASE DE FE. NO ES FANÁTICA.
LO POÉTICO ES LO TRANQUILO. COMO VER UN MUERTO SIN VER EL ACCIDENTE.
ES EL ESTADO INMEDIATO DESPUÉS DE LA ACCIÓN.
LA ESTELA DE AGUA - INMEDIATAMENTE.
NO ES LA ACCIÓN.
NO ES LA PALABRA PRONUNCIADA, SINO EL VIENTO CUANDO SE LA ESTÁ VICIANDO.
ES EL ECO. EL ESPACIO DE SILENCIO ENTRE ECO Y ECO.
FRACCIONES DE SEGUNDO DESPUÉS DE LO QUE SUCEDE, VACÍO DESPUÉS DE LA TURBULENCIA Y ANTES DE QUE DESAPAREZCA.
MOMENTO ENTRE LA APARICIÓN Y LA DESAPARICIÓN.
MOMENTO ENTRE EL HECHO YA HECHO Y SU IRREMEDIABLE OLVIDO.
YO FOTOGRAFÍO LO QUE YA SUCEDIÓ.
FOTOGRAFÍO LA ESTELA DE LO PASADO.

16. VIII. 94

I SAW IT, I DID IT.

THE JUSTIFICATION OF ACTIONS. A COMPREHENSIBLE METHOD THAT GENERATES A COMPREHENSIBLE FACT
THANKS TO THE METHOD, AND NOT TO THE FACT IN ITSELF. WE JUSTIFY OUR ACTS, WITH MULTIPLE
REASONS, FOR OTHER PEOPLE. ACT COMMUNICATED THROUGH THE COLLECTIVE CODE.
WHYS, FOR WHATS, EVEN IF THE RESULT IS A BREAD CRUMB; IF ONE UNDERSTANDS
THE METHOD, ONE UNDERSTANDS THE FACT.*

    FACTS (THINGS) SEEM DISORDERLY (THEY ARE NOT) AND WE
GIVE SENSE TO THEM.
    BUT YOU DO NOT SEE THE SAME WAY I DO. WHERE YOU SEE DISORDER OR BANALITY
I SEE MORE THAN A FEW REASONS AND MEANINGS. THAT LABYRINTH OF UGLINESSES WHICH
BECAUSE THEY ARE NEXT TO EACH OTHER WE CALL THE UNIVERSE. THOSE MULTIPLE DIRECTIONS HANGING
IN THE RIVER OF THAT WHICH WE CALL "GARBAGE."
    I SEE NO GREAT DIFFERENCE BETWEEN A CHINESE VASE AND A WAXED PAPER CUP
CRUSHED ON THE GROUND. I UNDERSTAND NEITHER OF THEM. BUT I HAVE THEM
IN FRONT OF ME AND I SEE THEM. I SEE THEM AS YOU SEE A PYRAMID. AS AN
UNKNOWN SYSTEM. THE OTHER, THAT IS REVEALED TO US. THE GODS OF OTHERS.
(I DO NOT BELONG TO THE PYRAMIDS EITHER.)
                THE INTENTION IS AN ACT.

(I DO NOT BELONG TO THE PYRAMIDS EITHER.)
THE INTENTION IS AN ACT.

*HOW MANY ACTS (PLANS, DESIRES) WE GUARD WITHIN OURSELVES WITHOUT BEING ABLE TO BRING THEM OUT BECAUSE WE CANNOT FIND THE METHOD, WHICH IS IN REALITY A DEMAND FROM OTHERS. THE REASONS FOR OUR INCOMPREHENSIBLE DESIRES. AND WE DO NOT ACT WITHOUT JUSTIFICATION.

THE PUBLIC NEEDS THE WHYS. WE DON'T.
THE OTHER
THE REST
THERE IS NO UNDERSTANDABLE, TOTAL, ILLUMINATING REASON FOR AN ACT OF LOVE.
THERE IS NO REASON FOR POETRY.
WHAT IS POETIC IS NOT THE RESULT OF A METHOD. IT IS NOT EVEN JUSTIFIABLE.
IT IS NOT EVEN BELIEVABLE.
HOW CAN WE BELIEVE IN THE POETIC? HOW CAN A RATIONAL SPIRIT BELIEVE IN THE INCOMPREHENSIBLE?
BELIEVING IS MENTAL. THE POETIC IS NOT EVEN IRRATIONAL. IT IS NOT EVEN EMOTIONAL. IT IS ANTI-RELIGIOUS.
IT IS ANOTHER SORT OF FAITH. IT IS NOT FANATICAL.
THE POETIC IS THE TRANQUIL. LIKE LOOKING AT A DEAD BODY WITHOUT SEEING THE ACCIDENT.
IT IS THE STATE IMMEDIATELY AFTER THE ACTION.
THE WAKE OF THE WATER. IMMEDIATELY.
IT IS NOT THE ACTION.
IT IS NOT THE SPOKEN WORD, BUT THE WIND CARRYING IT AWAY.
IT IS THE ECHO. THE SILENT SPACE BETWEEN ECHO AND ECHO.
FRACTIONS OF A SECOND AFTER WHAT HAPPENS, THE VOID AFTER THE TURBULENCE AND BEFORE IT DISAPPEARS.
THE MOMENT BETWEEN APPEARANCE AND DISAPPEARANCE.
THE MOMENT BETWEEN THE READYMADE FACT AND ITS IRREMEDIABLE FORGETTING.
I PHOTOGRAPH WHAT ALREADY HAS HAPPENED.
I PHOTOGRAPH THE WAKE OF THE PAST.

LO QUE YA PASÓ.

LO QUE ALGUIEN HA DEJADO.

UN PIANO LISTO PARA EL ALIENTO.

UN COCHE USADO.

UNA IDEA DE HACE MUCHOS AÑOS.

UN ALFABETO

UN RÍO DE BASURA.

ALGUIEN INVENTÓ UNA CAJA DE ZAPATOS BLANCA CON INTERIOR CAFÉ PÁLIDO.

ALGUIEN INVENTÓ LA BICICLETA. MÁS DE CUATRO USARON ESAS CUATRO BICICLETAS EN MÁS DE CUATRO DIRECCIONES.

ALGUIEN DESTRUYÓ Y ARROJÓ AL RÍO, PARA QUE YO LAS VIERA ESOS MUROS.

ALGUIEN PUSO ESOS POSTES DE MADERA CAMINO AL VOLCÁN, PARA ANUNCIAR EL PRINCIPIO DE LA NIEVE.

ALGUIEN TIRÓ ESAS NARANJAS Y LANZÓ ESOS MESAS.

ALGUIEN MÁS VIO ESE CHARCO.

ALGUIEN CORTÓ ESOS CÍRCULOS DE PLÁSTICO. ALGUIEN LOS ENCONTRÓ YA MOJADOS, DESPUÉS DEL REFLEJO.

ALGUIEN INVENTÓ LA PLASTILINA Y DE ALGUIEN ES ESTE POLLO.

ALGUIEN INVENTÓ EL TIEMPO Y DE ALGUIEN ES EL TIEMPO QUE SÉ ME OTORGA.

ALGUIEN, PRECISAMENTE ALGUIEN, ES EL DIRECTOR DE ESTE MUSEO.

ALGUIEN PISO ESOS POSTES DE MADERA CAMINO AL VOLCÁN, PARA QUE YO LOS VIERA ESOS MUROS.
LA NIEVE.
ALGUIEN TIRÓ ESAS NARANJAS Y VACIÓ ESAS MESAS.
ALGUIEN MÁS VIO ESE CHARCO.
ALGUIEN CORTÓ ESOS CÍRCULOS DE PLÁSTICO. ALGUIEN LOS ENCONTRÓ YA MOJADOS, DESPUÉS
DEL REFLEJO.
ALGUIEN INVENTÓ LA PLASTILINA Y DE ALGUIEN ES ESE POLVO.
ALGUIEN INVENTÓ EL TIEMPO Y DE ALGUIEN ES EL TIEMPO QUE SE ME OTORGA.
ALGUIEN, PRECISAMENTE ALGUIEN, ES EL DIRECTOR DE ESE MUSEO.
ALGUIEN PUSO UNA NARANJA EN LA VENTANA. SU

SON SUS RESTOS Y SUS ESTELAS
SON OTRAS ACCIONES ANTERIORES
LAS QUE ~~ACCIONAN AL PRESENTE~~ BORDEAN UNA POSIBLE VEREDA.
SON LOS RESTOS DE OTROS ANTERIORES EVENTOS LAS QUE ME HACEN CAMINAR Y DETENERME.

TODO ESTÁ HISTO. TODO ESTÁ HECHO. TODO HA SUCEDIDO.
YO TAN SOLO QUIERO ~~QUE~~ CONTINUARLO, POR UN MOMENTO.~ ~~Y MÁS ORDINARIO~~.

LO QUE ME SUCEDA, EN UN MUNDO DONDE YA TODO HA SUCEDIDO, ES EXTRAORDINARIO.
ES EXTRAORDINARIO QUE LO QUE YA SUCEDIÓ PROSIGA.~ ~~PROSIGA~~

ES EXTRAORDINARIO OLVIDARLO, PARA DESCUBRIR QUE RECORDAMOS.
INVENTAR ALGO QUE RECORDAMOS HABER VISTO.
EXTENDER LOS REFLEJOS.
ABRIR EL CLOSET PARA SACAR LO OSCURO.

THAT WHICH HAS HAPPENED.
THAT WHICH SOMEONE HAS LEFT.
A PIANO READY FOR A BREATH.
A USED CAR.
AN IDEA FROM MANY YEARS AGO.
AN ALPHABET
A RIVER OF GARBAGE.
SOMEONE INVENTED A WHITE SHOE BOX WITH A PALE BROWN INTERIOR.
SOMEONE INVENTED THE BICYCLE. MORE THAN FOUR USED THOSE FOUR BICYCLES IN MORE THAN
FOUR DIRECTIONS.
SOMEONE DESTROYED THOSE WALLS AND THREW THEM INTO THE RIVER, SO THAT I MAY SEE THEM.
SOMEONE PLACED THOSE WOODEN POSTS ALONG THE WAY TO THE VOLCANO, TO ANNOUNCE THE START OF
THE SNOW.
SOMEONE THREW THOSE ORANGES AND EMPTIED THOSE TABLES.
SOMEONE ELSE SAW THAT PUDDLE.
SOMEONE CUT OUT THOSE CIRCLES OF PLASTIC. SOMEONE FOUND THEM ALREADY WET, AFTER
THE REFLECTION.
SOMEONE INVENTED PLASTICINE AND THAT DUST IS SOMEONE'S.
SOMEONE INVENTED TIME AND FROM SOMEONE IS THE TIME THAT IS GRANTED TO ME.
SOMEONE, PRECISELY SOMEONE, IS THE DIRECTOR OF THAT MUSEUM.
SOMEONE PUT AN ORANGE IN HER WINDOW.

SOMEONE DESTROYED THOSE WALLS AND THREW THEM INTO THE RIVER, SO THAT I MAY SEE THEM.
SOMEONE PLACED THOSE WOODEN POSTS ALONG THE WAY TO THE VOLCANO TO ANNOUNCE THE START OF THE SNOW.
SOMEONE THREW THOSE ORANGES AND EMPTIED THOSE TABLES.
SOMEONE ELSE SAW THAT PUDDLE.
SOMEONE CUT OUT THOSE CIRCLES OF PLASTIC. SOMEONE FOUND THEM ALREADY WET, AFTER THE REFLECTION.
SOMEONE INVENTED PLASTICINE AND THAT DUST IS SOMEONE'S.
SOMEONE INVENTED TIME AND FROM SOMEONE IS THE TIME THAT IS GRANTED TO ME.
SOMEONE, PRECISELY SOMEONE, IS THE DIRECTOR OF THAT MUSEUM.
SOMEONE PUT AN ORANGE IN HER WINDOW.

THEY ARE HER REMAINS AND HER WAKES
THEY ARE OTHER EARLIER ACTIONS
THOSE THAT MOLD MY DESTINY BORDER A POSSIBLE PATH.
THEY ARE THE REMAINS OF OTHER EARLIER EVENTS THAT MAKE ME WALK AND STOP.

EVERYTHING IS READY. EVERYTHING IS DONE. EVERYTHING HAS HAPPENED.
I ONLY WANT TO CONTINUE IT, FOR A MOMENT.* AND THEN FORGET IT.

WHAT MAY HAPPEN TO ME, IN A WORLD WHERE EVERYTHING HAS ALREADY HAPPENED IS EXTRAORDINARY.
IT IS EXTRAORDINARY THAT WHAT HAS ALREADY HAPPENED SHOULD PROCEED. THANK YOU

IT IS EXTRAORDINARY TO FORGET IT, TO DISCOVER THAT WE REMEMBER.

TO INVENT SOMETHING THAT WE REMEMBER HAVING SEEN.

TO EXTEND THE REFLECTIONS.

TO OPEN THE CLOSET TO BRING OUT THE DARK.

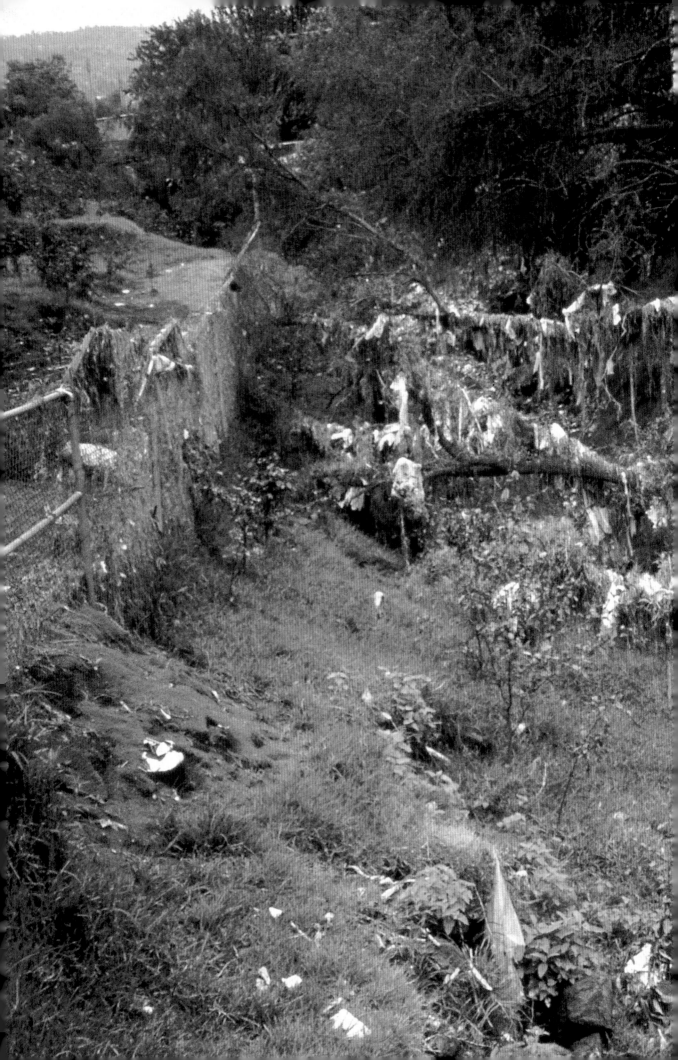

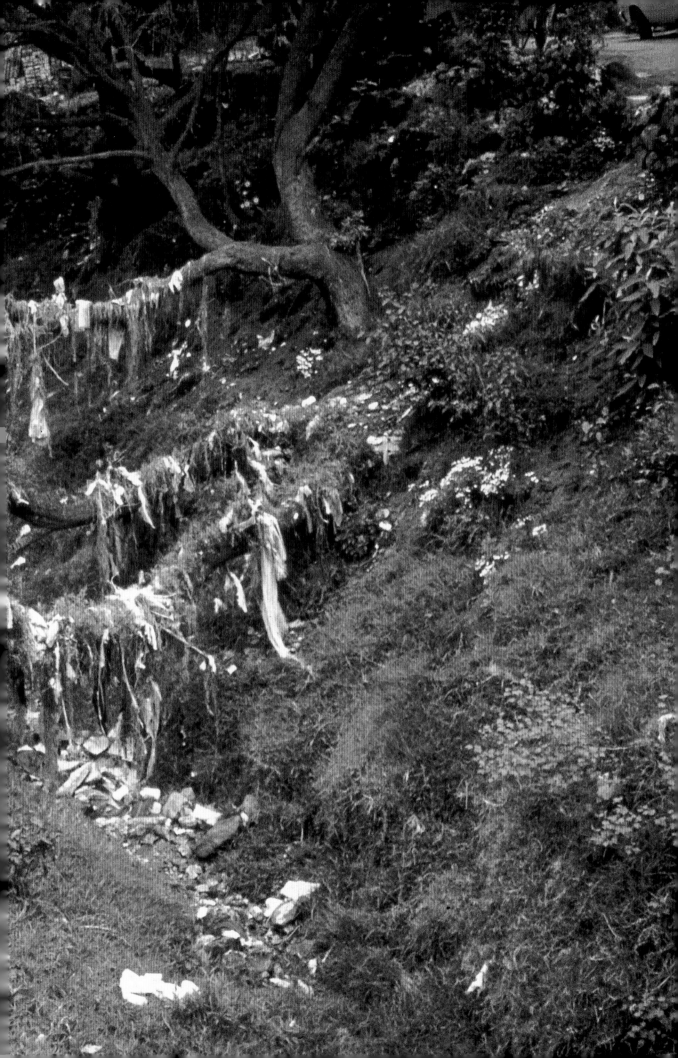

CORBATAS
RELOJES
DISCOS AZULES
ENREDADERAS
CARTERAS
LAMPARAS
ZAPATOS
MELONES
GUANTES
ESPUMA
CANICAS
SANDIAS
CALCETINES
CAPULLOS.

CAPULLOS
CALCETINES
SANDIAS
CANICAS
ESPUMA
GUANTES
MELONES
ZAPATOS
LAMPARAS
CARTERAS
ENREDADERAS
DISCOS AZULES
RELOJES
CORBATAS

CORBATAS CON CAPULLOS
SANDIAS AZULES
DISCOS DE SEMILLAS NEGRAS
ENREDADERAS DE CANICAS
CARTERAS DE ESPUMA
LAMPARA DE GUANTES

BUDS
SOCKS
WATERMELONS
MARBLES
FOAM
GLOVES
MELONS
SHOES
LAMPS
BRIEFCASES
VINES
BLUE DISCS
CLOCKS
TIES

TIES
CLOCKS
BLUE DISCS
VINES
BRIEFCASES
LAMPS
SHOES
MELONS
GLOVES
FOAM
MARBLES
WATERMELONS
SOCKS
BUDS

TIES WITH BUDS
BLUE WATERMELONS
DISCS OF BLACK SEEDS
VINES OF MARBLES
FOAM BRIEFCASES
LAMP OF GLOVES

# AFTERWORD

How do you take the weight out of sculpture? The question provides one way to consider the complex project that Gabriel Orozco has set for himself during the final years of this millennium. Sculpture traditionally has concerned an object or a body, implicitly weighty even if delicate or fragmentary. It remains fixed, and we move around it; it remains solid while the atmosphere changes. Yet over the centuries many artists have brought the beauties of lightness, actual and illusory, to the most heavy of art forms. This is the road Orozco has chosen, in part to assert his conviction that the aesthetic act takes place in an encounter, not in an object. But how does one arrive at lightness without merely making work that is small in size or idea?*

A consideration of lightness begins with Orozco's many pieces that involve the literal subtraction of mass. Most sensational, perhaps, was the exhibition at the Marian Goodman Gallery in New York, in 1994, where four clear Dannon yogurt container lids rimmed in blue hung on the white walls of an otherwise vacant room. It was a poem about nothing that, beautifully, could thus be one about everything too. A presence, however slight, was the key to seeing the emptiness of the room, as just a single sound is needed to manifest silence. A photograph of the installation shows the space bathed in luxurious soft blue light, lending it a celestial dimension.

In 1993, for an exhibition at the Galerie Chantal Crousel in Paris, Orozco had removed a lengthwise section—sixty-two centimeters (about 42 1/2 inches) wide—from the center of a Citroën DS and reconnected the two remaining sides. The result was dramatic, producing an exaggeratedly long and slender profile that made the car's famously fleet form look lighter yet. Photographs of *La DS* intensify the obvious readiness of the Citroën's nose—with headlight-nostrils—to zoom through space at lightning speed. One easily forgets that the car cannot move.

Orozco's art often toys with expectations of heaviness. *Recaptured Nature*, 1990, looks like a boulder but in fact is not much heavier than a large rubber ball, as it is made of reconfigured inner tubes filled with air. Another boulder-like sculpture, *Yielding Stone*, 1992, is made of plasticine; though solid, it is soft and malleable and far lighter than it would be in stone or metal. Rolled through the streets of Monterrey, Mexico, its surface took on external imprints, dust, and debris. By making the solid "stone" receptive, Orozco figuratively emptied it, creating an inside-out vessel. This transfer of emphasis from solid to surface is a clever lightening device that also occurs in Orozco's 1997 sculpture of a human skull with a graphite grid pattern that roams over the contours of the bone. The brain is conjured by the patterning that suggests the flow of thought inside a person's head. This act of sculptural lightening, and enlivening, is underscored by Orozco's title for the object, *Black Kites*.

In several of Orozco's pieces, the body of the artist is a reference point. Its presence is not advertised; neither is it kept secret. As a simple matter of fact, the yogurt caps were placed at the height of the artist's mouth. Orozco's own weight determined that of the plasticine *Yielding Stone*. In each of these instances the artist is expressly and precisely present. But this is only through Orozco's replacement or removal of himself—invisible, weightless, and I-less.

To lessen the weight of an object, one can either reduce the mass or reduce the force of gravity. We have seen that while Orozco's art literally effects the former, he cannot manipulate gravity. The great mass of the Earth exerts an inexorable attraction toward its center; it stabilizes us, our buildings, and all our heavy sculptures on the ground. Orozco's chance for a different gravitational field lies beyond the surface of the Earth, where the story is different. In outer space, although gravity pulls the planets toward the sun, their own powerful velocities provide an equal match for that attraction. As a result they remain in orbit. With gravity neutralized, the orbiting bodies are weightless.

In other words, one might think of anything on Earth as a sculpture with a pedestal that secures it to Earth. But one could think of Earth itself as a sculpture without a pedestal to secure it to anything—a circumstance precisely revealed by the Italian artist Piero Manzoni in 1961 when he provided it with one in his iron sculpture *Socle du monde* (Base of the world). The same holds true for the other planets revolving around the sun, and the moons revolving around the planets.

Circles, ever present in the art of Orozco, metaphorically link his art with the weightless realm of bodies in orbit. As a child in the 1960s Orozco grew up in the era of the astronauts, who gave us our first magical vision of an atmosphere liberated from the Earth's gravitational pull. Its images were those of lightness rather than heaviness—objects floating within a spaceship, man bouncing along the surface of the moon. Its picture of time was something that went around rather than forward. The circles that structure an extraordinary number of Orozco's sculptures, photographs, and drawings celebrate our existence on a round planet rotating on an axis and revolving in a solar system. They honor a notion of time that holds the promise of constant renewal rather than a unique origin and a single conclusion.

Orozco's circles take countless forms. In photographs, they can appear as cat food cans, oranges, the face of a wristwatch, a rubber ball, a cluster of sheep, and bicycle tracks. The early 1990s brought about a small cluster of spherical sculptures. The lightboxes that Orozco made in Korea in 1995 glow with bright circles of primary colors, while in a long-running series of collages circular patterns ornament airline tickets. Orozco's *Empty Club* project in London in 1996 filled a former gentlemen's club with circular and elliptical imagery—such as the *Oval Billiard Table*, over which hovers a red ball suspended by wire (a *perpetuum mobile* proving the earth's rotation), or the *Moon Trees*, artificial ficus trees adorned by white paper disks. Following a long sequence of sculptures with wheels as their dominant motif, in 1997

Orozco proposed for the Münster Sculpture Project a half-submerged Ferris wheel—its implied revolutions all the more emphatic as we wonder if they can proceed underground. And of course the circle is found in Orozco's name, where the o's ripple through all three syllables, roundly bringing back to front.

Orozco's "removals" have lightened sculpture of its load, and the imagery of the circle brings to his objects the metaphor of absolute weightlessness. Photography provides yet another means by which Orozco has freed sculpture of its weight. Throughout his work the two mediums enjoy a slip-sliding relation, collapsing into each other to the degree that one cannot discuss them separately. This holds true from the time of Orozco's first work in Mexico, where he performed "actions" resulting in sculptural tableaux that he then photographed. The sculptural situation existed for the sake of the photograph it would always be, while the situation itself was in most cases short lived.

Orozco has explored many possibilities inherent in the encounter of photography and sculpture. *My Hands are My Heart*, 1991, exists in both mediums. The sculpture, made in three versions, is a small red clay mass the approximate size of a human heart. A two-part photograph of the same title depicts its making: first, the impress of the artist's palms and fingers molding the clay, held in front of his body, and then, the hands opened to reveal the clay heart made from and by those hands. *Island within an Island*, 1994, is an image made possible only by a collaboration of sculpture and photography: Orozco's tiny skyscrapers of planks and debris create a micro-Manhattan skyline that gains meaning only when juxtaposed against the macro version. In certain cases, the fact of a photograph converts an unsuspecting target into what fairly can be called a sculpture. This effect is seen most dramatically in *Horse*, 1992, a creature standing still, seen compactly and directly from behind.

With these discoveries, interventions, and transformations, Orozco imposes no desire for permanence, and the act of composition prevails over that of construction. His art takes on the tone of play instead of labor. Orozco's work is very different from the photographs that document other artists' actions and performances of the 1960s and 1970s. Those explicitly serve as relics of the event and records of the persons involved, with the evocation of memory and history built into the meaning of the photographs. In Orozco's case the photographs seem in no way subordinate to the original sculptural event, and the emphasis rests upon their independent existence rather than the re-creation of an important moment.

When Orozco chooses to make autonomous sculptures, photography continues to play an important role. The six months of work spent drawing the skull that became *Black Kites* was documented in a great many photographs, only one of which the artist decided to print and title as an independent work of art: *Path of Thought*, 1997. *La DS* similarly yielded one such photograph, *Interior DS*, 1993, focusing on the rear window and the landscape-like appearance of the dust on its surface.

Orozco's conflating of sculpture and photography takes its place in the complex history of a sophisticated relationship between the two mediums. One of the most influential sculptures of the century, Marcel Duchamp's *Fountain*, 1917, is known in its original version only through a photograph by Alfred Stieglitz, taken before it was either lost or destroyed. Since its invention, sculptors have used photography to explore their own notions of their work and to mold the way in which it would be perceived by others. Constantin Brancusi used photographs to give his *Birds in Space* the freedom of flight that the marble or bronze sculptures never could have, even though he streamlined them to what literally could become the breaking point. And half a century later, artists such as Walter De Maria and Robert Smithson relied on photography as the means by which to convey the grandeur of the earthworks they erected in remote corners of the country.

*Photogravity*, Orozco's exhibition at the Philadelphia Museum of Art, extends this rich dialogue with disarming humor and audacity. *Photogravity* presents selections from a decade of his sculpture—all represented in life-size photographic surrogates. The photographs, cut to silhouette Orozco's objects, were applied on backing boards cut to match; supporting mounts designed by the artist allow them to stand as sculptures on the gallery floor. The black-and-white photographs translate the shapes of the sculptures from three dimensions to two. The result is altogether unfamiliar, given the distortions of perspective and the lack of contextual clues.

Orozco also presents photographic surrogates for a number of pre-Columbian sculptures in the collection of the Philadelphia Museum of Art. The original sculptures belong to the gift presented by Louise and Walter Arensberg to the Museum in 1950, almost two hundred pre-Columbian objects and a collection of modern art that includes the masterpieces of Brancusi and Duchamp. The photographs from which Orozco worked are those reproduced in the book, published in 1954, that celebrates the gift of the collection of pre-Columbian objects. Orozco enlarged and mounted the photographs approximately to match the sizes of the replicas of his own works of art. They share the space of a large day-lit gallery.

The new objects are both sculptures and photographs, but not fully either one. Although they are free-standing, one's experience of them is anything but sculptural: the objects are of minimal thickness, and the view from behind is but a blank surface and a stand. Relatively portable, they recall Duchamp's *Box-in-Valise*, and pay homage to his own fondness for traveling lightly. But their weirdly transformed state is less about a faithful reproduction of a sculpture and more about the creation of a strange new thing.

Orozco's presentation at first suggests the dialogue between modern and pre-Columbian art arranged by the Arensbergs in their home, and by the Museum in its inaugural installation. At the time, the juxtaposition reflected the collectors' joy in the discovery of an art that seemed to them as new as that of their contemporaries, despite its estimable age. It also showed the

Arensbergs' intuitive grasp of certain aesthetic parallels in the two bodies of work, such as the predominance of conceptual over naturalistic criteria of form. The counterpoint provided mutual validation as well as sympathetic company. Orozco also delights in the unexpected visual relationships that can be drawn between his sculptures and those of many centuries ago.

Yet Orozco's exhibition bears a crucial difference from the Arensbergs' mingling of pre-Columbian and contemporary work: he does not juxtapose the real objects. Instead he creates a conjunction of two friendly phantoms. Suddenly, the opportunity for comparisons and contrasts—didactic oppositions of the "modern" and the "primitive"—is gone. Orozco creates a neutral ground on which all the objects seem much more alike than they really are. Major variations in size and weight are erased, and their surfaces have been homogenized by the gray/white spectrum and glossy coating of the photographic print. Vast differences in original context and function, centuries apart, are wholly obliterated. To some extent, in the process the one becomes the other, with circular reciprocity. The pre-Columbian objects present themselves as works of contemporary art. Orozco's contemporary sculptures convincingly pose as ancient Mexican. They seem as archaeological as the objects from Teotihuacán or Tenochtitlán; those objects seem as fresh as Orozco's own.

Through the relatively simple and inexpensive use of photography, Orozco has bypassed the Western tendency to consume the art of unfamiliar cultures. Picasso's relation to a tribal object he admired was as preemptive as that of his culture: take it and turn it into a Picasso. In parallel fashion, many a modern collector or museum saw fit to acquire such an object and display it as a work of art. At the end of the millennium, Orozco wants to complicate those unidirectional moves and set up an interchange rather than a takeover. Photography has provided one means of so doing. Since its inception, photography has been an ally of the tourist, imposing the Western eye on the exotic "other." Orozco has transformed its role to one that catalyzes reciprocal forces of attraction.

This exhibition deepens Orozco's ongoing inquiry into the relationship between object and image. A sculpture can be a three-dimensional photograph; a photograph can be a two-dimensional sculpture. Distinctions between image and object probably have never been as sharp as they may seem, but Orozco draws attention to the ambiguities and the rich opportunities that lie therein. A different perspective is enough to transform structure to surface, to convert volume to line—to change the weight of the world around us. In Orozco's realm of photogravity, polarities of light and heavy, full and empty, inside and outside, disappear.

*"Lightness" is the first of Italo Calvino's *Six Memos for the Next Millennium* (Cambridge: Harvard University Press, 1988).

# LIST OF ILLUSTRATIONS

Fragments of pages from Gabriel Orozco's notebooks, 1992–99, photographed by the artist [English translation pages enclosed in brackets]:

Pp. 2 [p. 3], 6 [10], 8 [11], 12 [13], 16 [17], 18 [19], 22 [24], 26 [27], 30 [31], 32 [33], 36 [37], 38 [39], 40 [41], 44 [45], 48 [50], 54 [56], 60 [61], 62 [63], 68 [69], 74–75 [76–77], 78–79, 82 [86], 83 [87], 90 [94], 91 [95], 92, 93, 96, 98 [102], 100 [103], 104 [106], 105 [107], 110, 114, 116 [121], 120 [121], 124 [128], 125 [129], 126 [130], 127 [131], 136 [138], 140 [142], 144 [145], 146 [148], 147 [149], 152 [154], 156 [158], 160–61 [162–63], 164–65 [166–67], 170 [171]

Pre-Columbian objects from the Louise and Walter Arensberg Collection, Philadelphia Museum of Art [photographs from the catalogue *The Louise and Walter Arensberg Collection: Pre-Columbian Sculpture*, published by the Philadelphia Museum of Art in 1954]:

Pp. 9,* 25, 43, 51, 53, 65, 66, 73, 88–89,* 97, 109, 122, 135, 157

## Works by Gabriel Orozco

Page 7: *Elevator*, 1994
Altered elevator cabin; 8 x 8 x 5' (243.8 x 243.8 x 152.4 cm)

Pages 14 and 15: *Traffic Worm*, 1993
Cibachrome; 12 7/16 x 18 5/8" (31.6 x 47.3 cm)

Page 20: *Mil pesos* (Thousand pesos), 1996
Collage, peso note, letterset pen, paint; 11 x 8 1/2" (27.9 x 21.6 cm)

Page 21: *Eaten Hose*, 1990
Cibachrome; 12 7/16 x 18 5/8" (31.6 x 47.3 cm)

Page 23: *Recaptured Nature*, 1990
Vulcanized rubber; diameter 37 3/8" (94.9 cm)

Pages 28 and 29: *House and Rain*, 1998
Cibachrome; 16 x 20" (40.6 x 50.8 cm)

Pages 34 and 35: *Recaptured Nature*, 1990
Vulcanized rubber; diameter 37 3/8" (94.9 cm)

Page 42: *Atomists: Offside*, 1996
Two-part computer generated print, plastic coated; 78 1/2 x 62 1/4" (199.4 x 158.1 cm)

Pages 46 and 47: *Extension of Reflection*, 1992
Cibachrome; 12 7/16 x 18 5/8" (31.6 x 47.3 cm)

Page 49: *Lost Line*, 1993
Cotton and plasticine; diameter 15 3/4" (40 cm)

Page 52: *Butterfly Effect*, 1998
Collage; 11 3/4 x 9 1/4" (29.8 x 23.5 cm)

Page 55: *Orange without Space*, 1993
Orange and plasticine; diameter 19 11/16" (50 cm)

Page 57: *Mexico-New York*, 1997
Collage, airline ticket, cutouts, pen, paint; 11 x 8 1/2" (27.9 x 21.6 cm)

Pages 58 and 59: *Crazy Tourist*, 1991
Cibachrome; 12 7/16 x 18 5/8" (31.6 x 47.3 cm)

Page 64: Detail of *La DS*, 1993
Altered Citroën DS; 189 x 44 7/8 x 333 5/8" (480 x 114 x 847.4 cm)

Page 67: *Habemus Vespam*,* 1995–96
Samico stone; 45 3/8 x 24 7/8 x 70 7/8" (115 x 63 x 180 cm)

Pages 70 and 71: *Cats and Watermelons*, 1992
Cibachrome; 12 7/16 x 18 5/8" (31.6 x 47.3 cm)

Page 72: Detail of *La DS*, 1993
Altered Citroën DS; 189 x 44 7/8 x 333 5/8" (480 x 114 x 847.4 cm)

Pages 80 and 81: *Island within an Island*, 1994
Cibachrome; 12 7/16 x 18 5/8" (31.6 x 47.3 cm)

Pages 84 and 85: *La DS*, 1993
Altered Citroën DS; 189 x 44 7/8 x 333 5/8" (480 x 114 x 847.4 cm)

Page 99: *Yielding Stone*, 1992
Plasticine and dust; diameter 19" (48.3 cm), weight 132.2 lb (60 kg)

Page 101: *Yielding Stone*, 1992
Plasticine and dust; diameter 19" (48.3 cm), weight 132.2 lb (60 kg)

Page 108: *Un peso* (One peso), 1996
Collage, peso note, letterset pen, paint; 11 x 8 1/2" (27.9 x 21.6 cm)

Page 111: *Raspado* (Scraping), 1997
Collage, back of ticket with red carbon, red carbon circle, red smudge;
11 x 8 1/2" (27.9 x 21.6 cm)

Pages 112 and 113: *Four Bicycles (There is Always One Direction)*, 1994
Bicycles; 78 x 88 x 88" (198.1 x 223.5 x 223.5 cm)

Page 115: *Cupón de equipaje* (Baggage claim ticket), 1997
Collage, airline ticket, cutouts, paint; 11 x 8 1/2" (27.9 x 21.6 cm)

Page 117: *Mani melone* (Melon hands), 1995
Paper maché; 5 1/2 x 7 7/8 x 4 3/4" (14 x 20 x 12.1 cm)

Pages 118 and 119: *My Hands are My Heart*, 1991
Two-part cibachrome; each 9 1/8 x 12 1/2" (23.2 x 31.8 cm)

Page 123: *Pinched Star III*,* 1997
Cast aluminum; 20 1/2 x 14 1/4 x 12" (52.1 x 36.2 x 30.5 cm)

Pages 132 and 133: *Chalma*, 1992
Cibachrome; 12 7/16 x 18 5/8" (31.6 x 47.3 cm)

Page 134: *Eroded Suizeki*, 1998
Collage; 11 1/4 x 8 1/8" (28.6 x 20.6 cm)

Page 137: *Pinched Star II*, 1997
Cast aluminum; 22 x 17 1/2 x 10 3/8" (55.9 x 44.5 x 26.4 cm)

Page 139: *Pinched Star I,*\* 1997
Cast aluminum; 31 x 23 x 15" (78 x 58.4 x 38.1 cm)

Page 141: Detail of *Pinched Ball*, 1993
Cibachrome; 12 7/16 x 18 5/8" (31.6 x 47.3 cm)

Page 143: *Black Kites*, 1997
Graphite on skull; 8 1/2 x 5 x 6 1/4" (21.6 x 12.7 x 15.9 cm)

Page 150: *Charco #49* (Puddle #49), 1997
Gouache on laser print; 11 x 8 1/2" (27.9 x 21.6 cm)

Page 151: *Black Kites*, 1997
Graphite on skull; 8 1/2 x 5 x 6 1/4" (21.6 x 12.7 x 15.9 cm)

Page 153: *Path of Thought*, 1997
Cibachrome; 12 7/16 x 18 5/8" (31.6 x 47.3 cm)

Page 155: Detail of *Horse*, 1992
Cibachrome; 18 5/8 x 12 7/16" (47.3 x 31.6 cm)

Page 159: *Chair with Cane*, 1990
Cibachrome; 18 5/8 x 12 7/16" (47.3 x 31.6 cm)

Pages 168 and 169: *River of Trash*, 1990
Cibachrome; 12 7/16 x 18 5/8" (31.6 x 47.3 cm)

Page 172: My Grandmother's Pot

\* Original images reversed

Published on the occasion of an exhibition at the Philadelphia Museum of Art, October 27–December 12, 1999

The exhibition and publication were supported by a grant from the Philadelphia Exhibitions Initiative, a program funded by The Pew Charitable Trusts, and administered by The University of the Arts, Philadelphia.

Curators: ANN TEMKIN and SUSAN ROSENBERG
Designer: LUC DERYCKE.
Editor: MORGEN CHESHIRE
Translator: JILL CORNER

Gabriel Orozco would like to thank: ANNE D'HARNONCOURT,
ANN TEMKIN, SUSAN ROSENBERG, DARIELLE MASON;
LUC DERYCKE, MORGEN CHESHIRE, JILL CORNER, GEORGE MARCUS;
CATHERINE BELLOY, ELAINE BUDIN, ANDREW RICHARDS,
MARIAN GOODMAN, CHANTAL CROUSEL, MONICA MANZUTTO, JOSE KURI;
SAM KUSAK, SARA CHAVEZ, CRISTINA FELIX,
GOLDE y JUAN GUTIERREZ, MARIA GUITIERREZ
y a MARTINEZ con cariño.

Produced by the Department of Publishing
Philadelphia Museum of Art
Benjamin Franklin Parkway at Twenty-sixth Street
P.O. Box 7646
Philadelphia, PA 19101-7646

US ISBN (0-87633-128-2)

Library of Congress catalog card number: 99-04-87-94

Distributed by D.A.P.
155 Sixth Avenue
New York, NY 10013-1507
T 212-627-1999/F 212-627-9484

Co-published in Europe by Luc Derycke, *uitgever*
Lange Steenstraat 10, B-9000 Gent, Belgium
T +32 9 329 31 22/F +32 9 329 31 23

ISBN 90-6917-004-3

D/1999/7852/4

Distributed by Exhibitions International
Kol. Bégaultlaan 17, B-3012 Leuven, Belgium
T +32 16 29 6900/F +32 16 29 6129

Printed and bound in Belgium

Cover: *Black Kites*, 1997
Graphite on skull; 8 1/2 x 5 x 6 1/4" (21.6 x 12.7 x 15.9 cm)

Back cover: Detail of *Horse*, 1992
Cibachrome; 18 5/8 x 12 7/16" (47.3 x 31.6 cm)

Endpapers: Fragments from Gabriel Orozco's notebooks, 1992–99, photographed by the artist.

16 VIII 94